Rix Mills Remembered

Rix Mills Remembered

An Appalachian Boyhood

Paul W. Patton

THE KENT STATE UNIVERSITY PRESS • KENT & LONDON

This publication was made possible in part through the generous support of John Doyle Ong.

Library of Congress Catalog Card Number 2002066088

ISBN 0-87338-753-8

Manufactured in China

07 06 05 04 03 5 4 3 2 1

Library of Congress Cataloging-in-Publication Data

Patton, Paul W., 1921—

Rix Mills remembered : an Appalachian boyhood / Paul W. Patton.

p. cm.

ISBN 0-87338-753-8 (alk. paper) ∞

1. Patton, Paul W., 1921–1999.

2. Artists—Ohio—Rix Mills—Biography.

3. Rix Mills (Ohio)—In art.

4. Rix Mills (Ohio)—History.

I. Title.

ND237.P2544 A2 2003

759'.13—dc21

2002066088

British Library Cataloging-in-Publication data are available.

For Susan and Wendy,

Caitlin, Jackson, and Grace

Contents

Remembering Rix Mills

On my twentieth birthday, December 7, 1941, the world of my youth ended with the Japanese attack on Pearl Harbor and the entrance of the United States into World War II. At the end of my first quarter at Ohio State University, in January 1942, I enlisted.

But first I came back to Rix Mills for the last time before I went to war. I can still see the village I left in my mind's eye: a cluster of rooftops and a church spire spread along both sides of a gravel road in the Appalachian foothills of Muskingum County in southeastern Ohio.

When my father died, my widowed mother brought her six children back to Rix Mills. I was the youngest, a year old. Country boys like me grew up in the 1920s and 1930s milking cows, shocking wheat, and driving teams of horses in the fields pulling farm machinery. Electricity and plumbing had not yet reached us.

Half a century later, in retirement, I discovered the coal banks that dotted every hillside around Rix Mills had been emptied by strip-mining shovels. The farms that had once surrounded the village were gone, along with roads I walked as a boy and the woods I knew. Even Ben St. Clair's big hill across the road from our house was gone, leaving a lonesome place in the sky.

Outside of Rix Mills, near Cumberland, high fences now surround thousands of acres where wheat and corn and hay once grew. Endangered species of animals from around the world roam safe on land where Jersey cattle and Hampshire hogs were once raised. Where 4-H clubs played baseball on soft summer evenings, tourists now come to see the animals in The Wilds.

The village I knew so well as a boy remains dear to my heart. But except for the Rix Mills Church and a few houses, nearly every vestige of our way of life is gone. All that is left are memories. These are my memories of growing up in rural Appalachian Ohio in the years between the two World Wars.

<div align="right">Paul W. Patton, 1998</div>

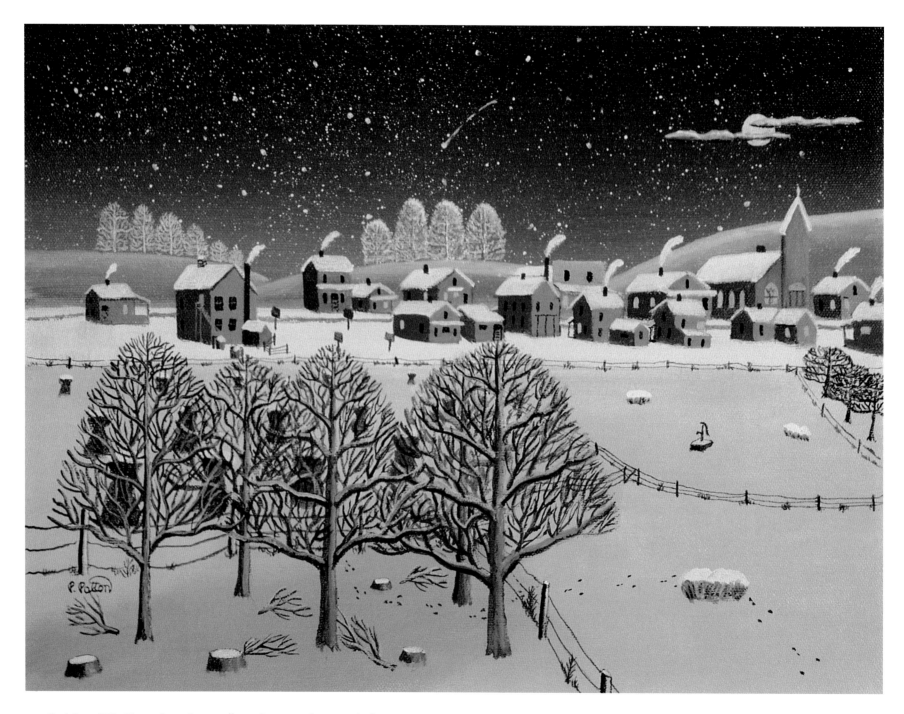

2 *Hugh Patton's Wood Lot.* 11" x 14", 1996, #504. Courtesy of James Lubetkin.

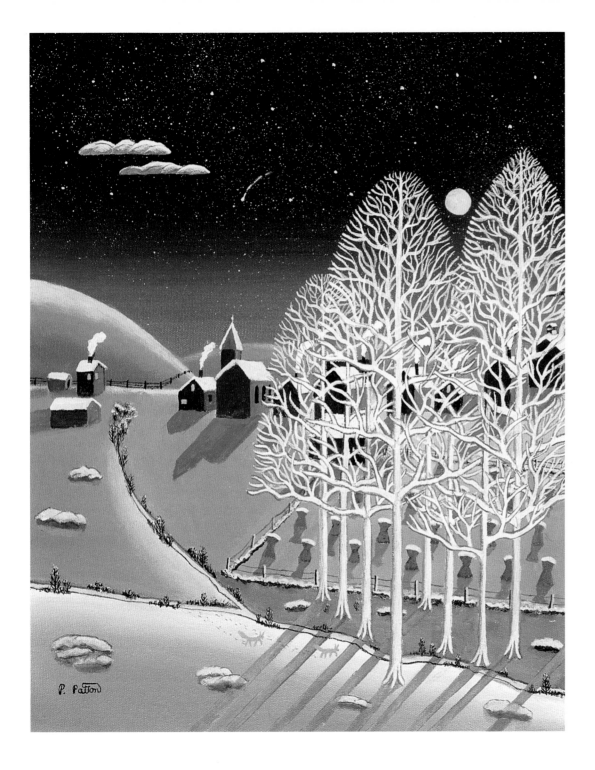

Winter Nightfall. 18" x 14", 1995,
#461. Featured on the cover of
Ohio Magazine, Dec./Jan. 1996.

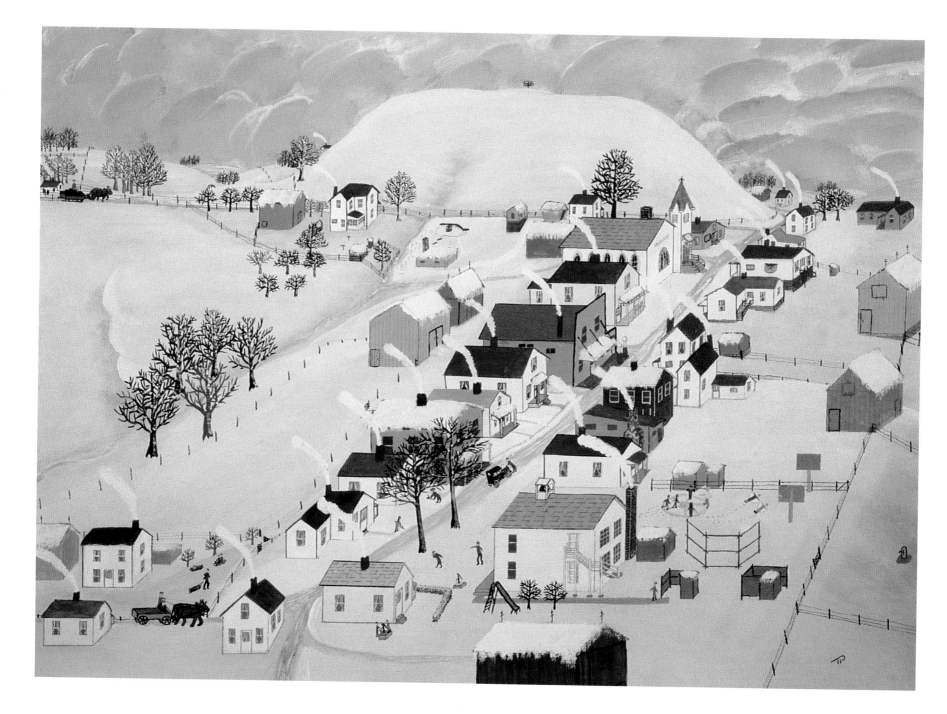

4 *Winter Snow Storm.* 20" x 24" on masonite, 1988, #108. Courtesy of Nonni Casino.

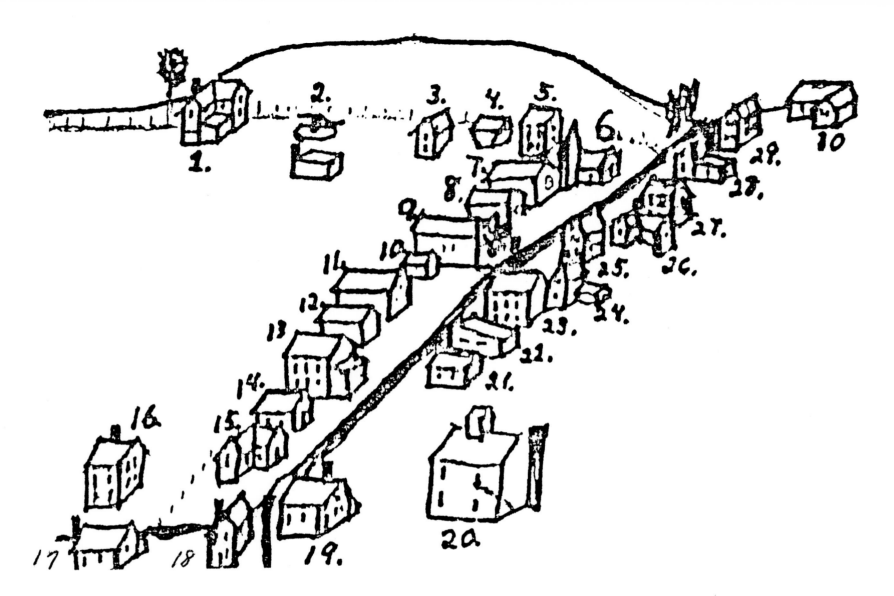

Rix Mills, Ohio.

1. Ethel Patton Family.
2. Sorghum mill.
3. Carpenter shop.
4. Coal scales.
5. Myrtle and Emery Watson.
6. Lizzie Leedom and Martha Patton.
7. United Presbyterian Church.
8. Parsonage.
9. Ledman-Watson General Store.
10. Doctor's office.
11. Lee Davis.
12. Phone switchboard, A. Watson home
13. Billy Messick store.
14. Hop Miller home.
15. Kate and John Barnett.
16. Joe Grimes home.
17. McKinney home.
18. Mary Ray family.
19. Kate and Jim Ledman home.
20. Rix Mills School.
21. Warney Young home.
22. Blacksmith shop.
23. Barnett store.
24. Billy Barnett home.
25. Ada and Campbell Watson.
26. Lizzie and Mayn Forsythe.
27. Sadie and J. W. Lyons home.
28. Olney Gilogley home.
29. Mag and Al Warne home.
30. Kate and Jim Kirk home.

The Village

A Boy's World

Rix Mills was nestled close in at the foot of Ben St. Clair's big hill. We lived on one acre of land on the Claysville Road just across from the field where Ben pastured his cows. I liked to climb the hill at dusk and survey the village and farms below me, spread out until they reached the hills in the distance. I knew little of life outside that bowl, but I knew much about my own world inside it.

I knew where to find the raspberry bushes hidden on Emery Watson's worm fence, and where to find blackberries as big as a fat man's thumb. I knew where I could gather hickory nuts and walnuts and which farms had chestnut trees. I knew exactly how far Pete Henderson's chestnut tree was from the hedge I crawled through. I knew where rabbits hid in their favorite briar patches, which trees were home to squirrels, and where skunks had their dens in the woods back of Joe Grimes's sorghum mill.

Rich Hill Township folks didn't travel much in the 1920s. Life centered at home. Saturday-night visits to the general store in Rix Mills or Freeland or Spratt, Sabbath morning at church, and once-a-year visits to Zanesville for the Muskingum County Fair were the high points of rural life in the countryside around Rix Mills in those days.

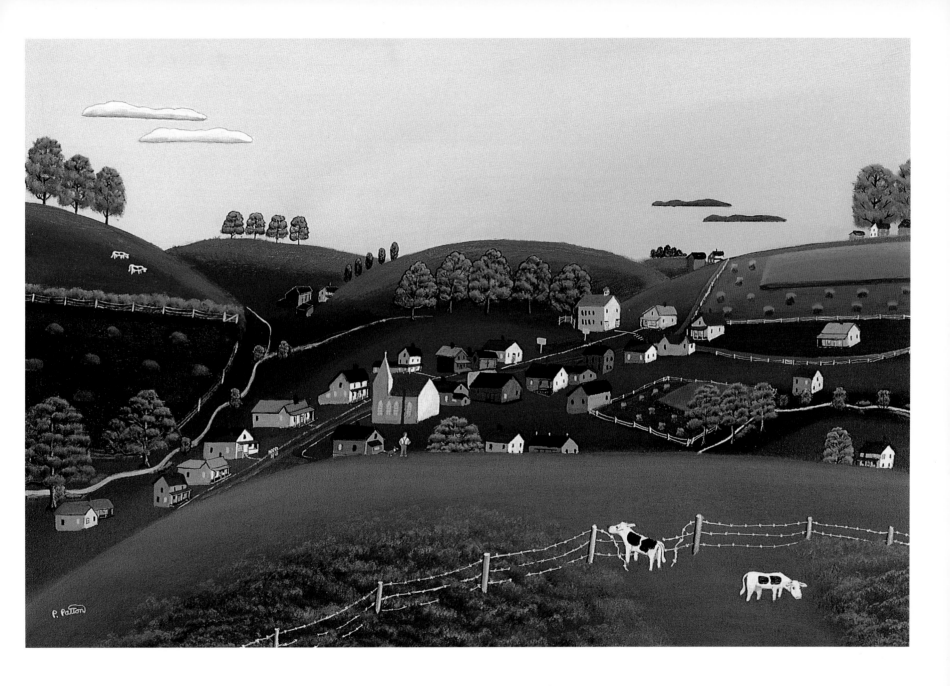

A Boy's World. 20" x 30", 1992, #305. Courtesy of Lloyd White and Joanna Hart.

Ben St. Clair's Cows

Many of my Rix Mills paintings show Ben St. Clair's hill, which was dear to my heart. I remember the hill soaring high above the village, though people today tell me it really wasn't that high. The hill was a blackberry patch in season, a haven for rabbits, and a young people's park for winter sledding and summer parties.

But it was basically a pasture for Ben's cows, which were generally out there. The hill field was just across the road from our house, so I was well acquainted with his cows. Mostly they ignored me and my dog Rags on our frequent visits to their pasture, although once in awhile they would meander over to me for a handout.

Most Rix Mills farmers preferred Jersey cattle for the high butterfat content in their milk. Ben generally had Holsteins, which gave more gallons, but had less butterfat.

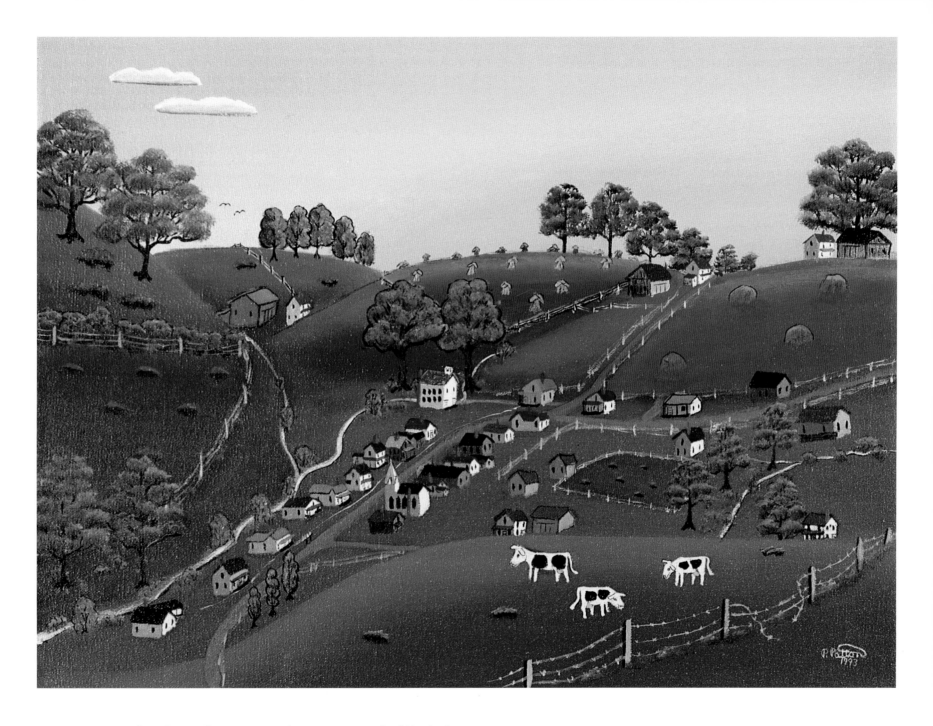

Ben St. Clair's Cows. 14" x 18", 1993, #369. Courtesy of University Hospitals of Cleveland.

The Ethel Patton Family and Our Rix Mills Home

Our home stood at the edge of Rix Mills. (It still stands, now the home of Dale and Nancy Shepherd, and the road is called Shepherd Road.) When my father, Clark Patton, died in a steel mill accident in Alliance, Ohio, I was a year old. My mother, thirty-one years old, returned with her six children to Rix Mills the following year, 1922.

Our house was on the Claysville Road at the edge of the village, across the road from Ben St. Clair's hill. We used almost every square foot of our acre to grow food. Ten fruit trees in our large side yard supplied us with apples, cherries, and pears. Our small barnyard and hog lot had more trees: apple, sickle pears, a white butter peach, and quince bushes.

The rich black loam of our garden grew potatoes, beans, tomatoes, corn, cabbage, celery, and more. It reneged only in growing muskmelons. All summer long my mother canned, cold-packed, or stored fruit and vegetables in our root cellar or in glass jars on the shelves that lined the walls of our small basement.

Chickens were always underfoot, laying eggs or growing into Sunday dinner. Our two spring piglets became pork chops, ham, bacon, and home-canned pork tenderloin in November, when an Elliott uncle did our butchering for us. We had our own cow, which provided milk for drinking and cream for churning into butter and skimming to mix with middlings to feed our pigs.

We had a screened-in back porch where we ate in the summer. Outside the house we had a coalhouse close to the kitchen door, an outhouse, a chicken coop, and a barn. Inside the house we had a potbelly stove in the living room. While the countryside relied on coal- and wood-burning cookstoves as well as coal oil lamps, we had gaslight and gas stoves in Rix Mills. In the summer we took the potbelly stove down and stored it in the coalhouse. Marion could play the piano in the parlor, which was used only on special occasions.

Our drinking water came by the bucketful from Emery Watson's well, up the road from us. For washing, we pumped rain water in our cistern up to the kitchen. A bath meant heating water on the stove, pouring it into a basin, and securing a small private corner of the kitchen. Bathrooms in the village and countryside were small wooden outhouses, or privies.

There were six of us. Marion and Robert were the oldest. When we came to Rix Mills in 1922, they got jobs as school janitors for the Rix Mills grade school and the two-year high school classroom above it. Marion also worked for Alma Watson and the farmers' exchange telephone system, tending switchboard in Alma's house at night and on weekends for eight cents an hour.

Marion teased Robert unmercifully. When we were asleep at night, sometimes she would come into the boys' room, creep under Robert's bed, and raise the

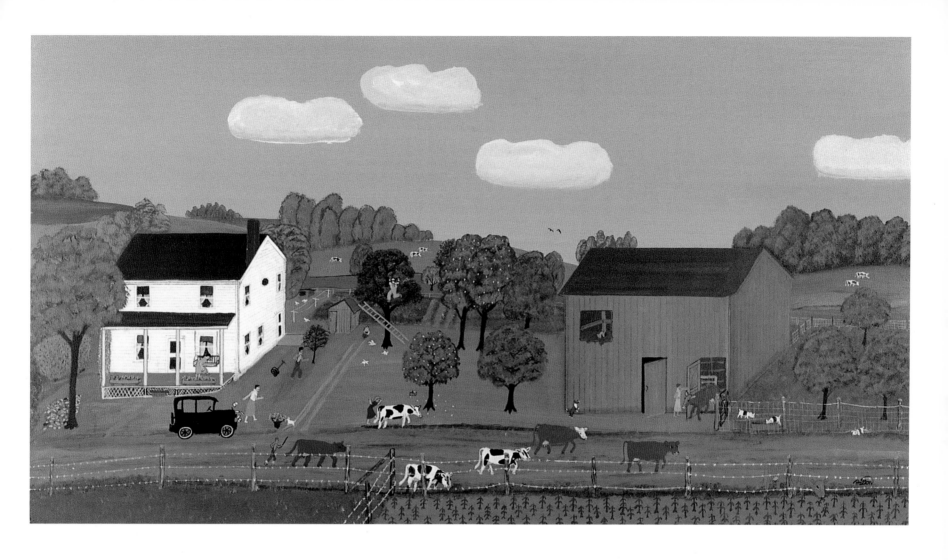

The Ethel Patton Family. 16" x 30" on masonite, 1988, #125. Courtesy of Dorothy Abbott Patton.

mattress and moan. She petrified us. The girls' bedroom floor must still be scarred from the firecracker she set off there one Fourth of July.

Carol and Ralph were the middle children. Ralph was very competitive; when they quarreled, sometimes he would put a headlock on Carol, and my mother would have to intervene.

Dorothy and I were the youngest. We drove our cow, along with Emery Watson's cows, to and from the pasture every summer day in the Mooreheads' back forty. Early on, we roamed the fields, fished the creeks, and cut ice from the creeks for ice cream in the winter.

Our Rix Mills Home. 14" x 18" on canvasboard, 1990, #205. Courtesy of Dorothy Abbott Patton.

Every Monday

Monday was wash day. Our Mondays started with heating water from the cistern in a copper boiler on our two-burner hot plate in the corner of the basement. (We were lucky. Farm families had to heat their wash water on their wood- or coal-burning cookstoves.) Then we poured the hot water by the bucketful into our hand-operated wooden washing machine.

Fels Naptha soap was added along with the first load of clothes, white and light. I hand-pumped the washer, 500 strokes for white clothes, 900 for overalls. My mother scrubbed, rinsed the clothes in a tub of water to which bluing had been added for whiteness, and put the clothes through the hand-wringer. Then my sister Dorothy hung the wash outside on the line to dry in the sun.

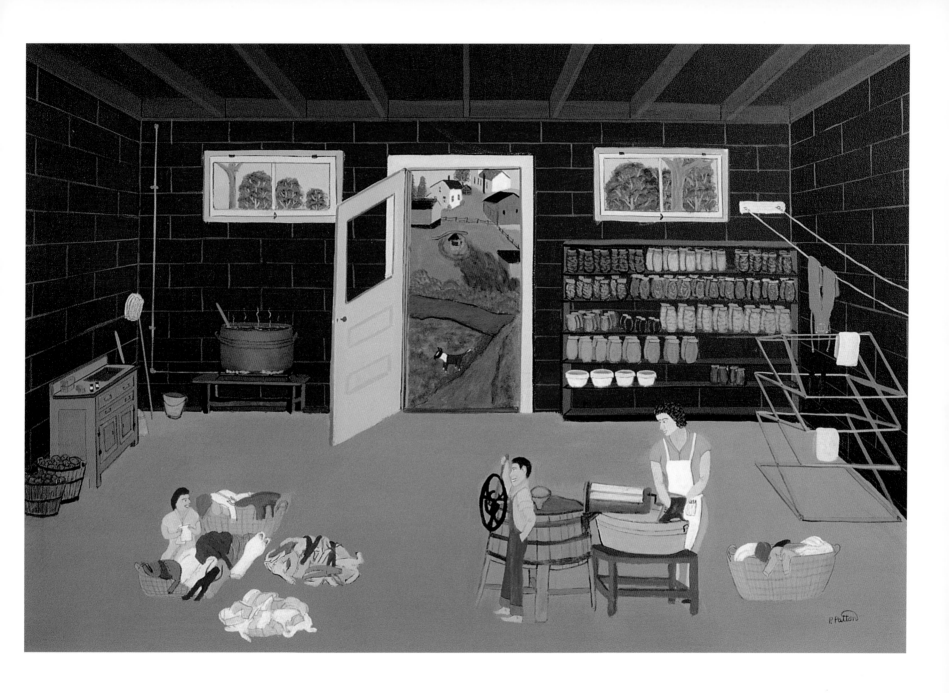

Every Monday. 20" x 30", 1992, #302. Courtesy of Wendy Patton (Garrity).

Pete and the Rosebush

Sheep were not plentiful on the farms around Rix Mills. So when Uncle Ray Elliott offered us a lamb, whose twin had the exclusive attention of the ewe, we were more than glad to accept.

We made a soft bed for it in the barn, took turns bottle-feeding it, and named it Pete. Soon Pete followed us everywhere. Pete flourished and grew, but in time he developed an aggressive disposition and a taste for my mother's rosebush.

The day came when Pete was given back to Uncle Ray. Several months later we had mutton for supper. Dorothy said, "It's Pete and I won't touch it." No one else touched it, either, and to this day I don't care for lamb.

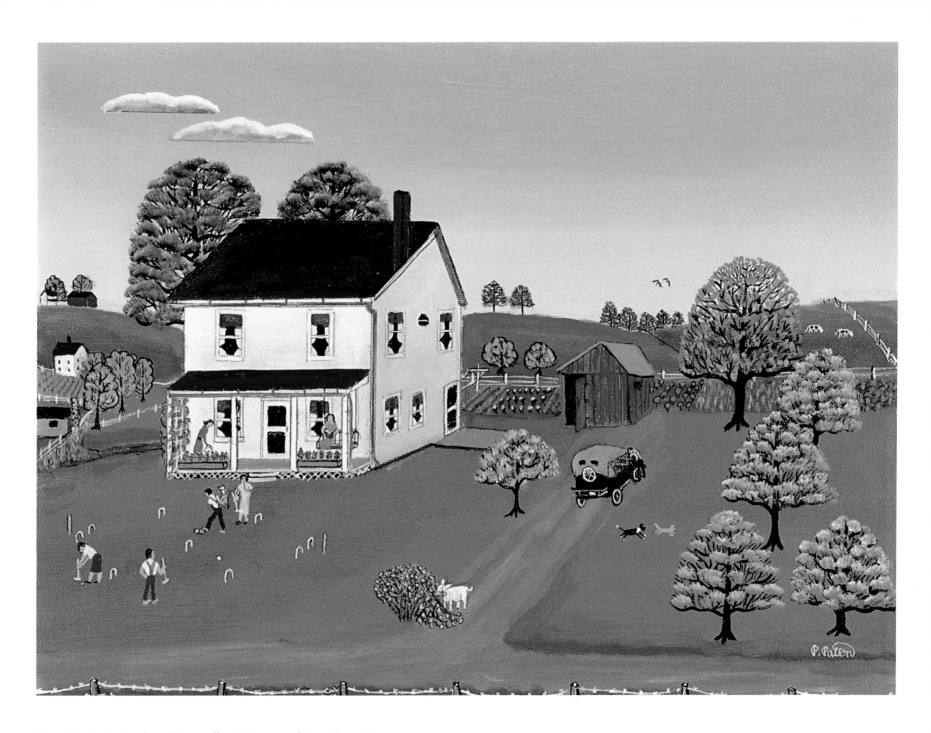

Pete and the Rosebush. 14" x 18", 1994, #448. Courtesy of Susan Patton-Fox.

Learning to Milk

Our cow, Lady, gave us gallons of milk and many head-aches. One of our Elliott uncles got the cow for us from a farmer over near Bloomfield. He called her Diablo because she jumped fences, and I have no doubt we received a price advantage. She liked to jump barbed-wire fences for us, too, and was often found miles and hours away from her pasture.

Milking the cow was considered to be a boy's chore. When my oldest brother, Robert, was recruited to live with Harry Kirk's family in Cambridge to finish high school and play football and basketball for Harry, the coach, the job fell to Ralph. He hated it. When Lady misbehaved, Ralph would give her a kick. When he finally got her tied to a fencepost and started to milk her, she would invariably slap him in the face with her tail and kick the bucket.

I was five years younger than Ralph. When I was eight, Ralph offered to teach me to milk, and I was de-lighted. He encouraged me to seek out Lady in the pas-ture and, with pats, to bring her to the feeding and milking spot in the corner of the field. Then he in-structed me in the fine art of milking and gave me much praise for what he called "my marvelous way with animals." I took over the milking chores and never real-ized until I was sixteen that Ralph had outmaneuvered me. By that time Ralph was at Muskingum College.

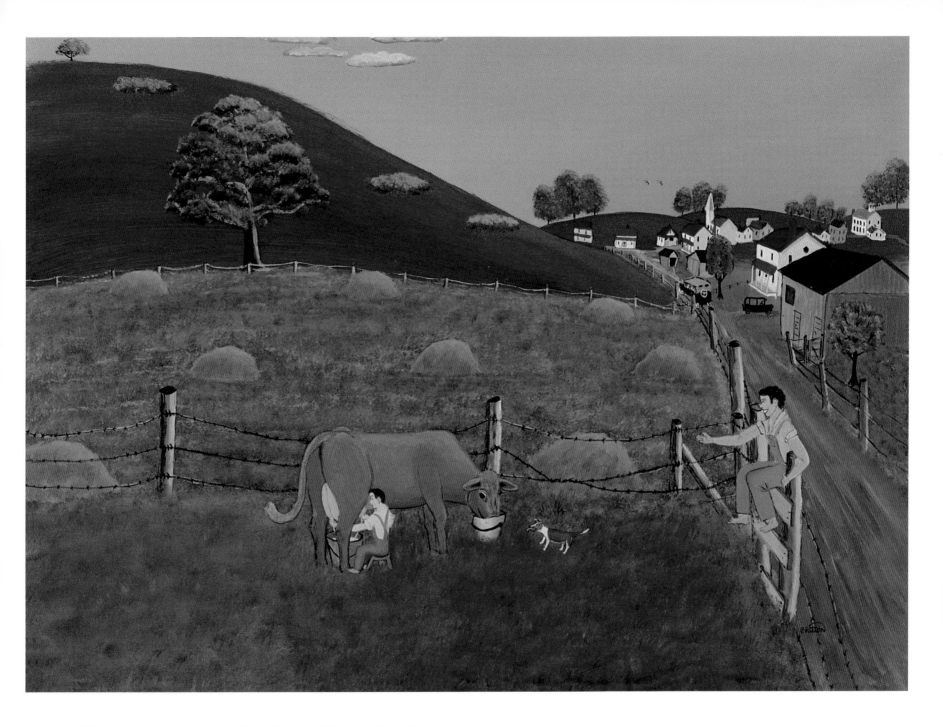

Learning to Milk. 18" x 24" on masonite, 1991, #278. Courtesy of Leon and Gloria Plevin.

Neighbors on the Claysville Road

Emery Watson was our neighbor on the Claysville Road. His coal bank was about a quarter of a mile down the road, between our house and the Moorehead farm. The platform scale for weighing farmers' wagonloads of coal was next door to Emery's house, and it looked something like a covered bridge.

In the painting, Emery is weighing the coal and his wife, Myrtle, is working in their garden. J. W. Lyons, the Rix Mills Church custodian, is at work in his carpenter shop next to Emery's. Between J. W.'s carpenter shop and our house is Joe Grimes's sorghum mill.

It is fall, and the mill is in full swing. Steam is pouring out of the evaporator shed, and Joe's horse Molly is circling round and round the mill, turning the press. I stand in Ben St. Clair's pasture with our cow, Lady, waving at my friends, the Aitkens, as the family drives by.

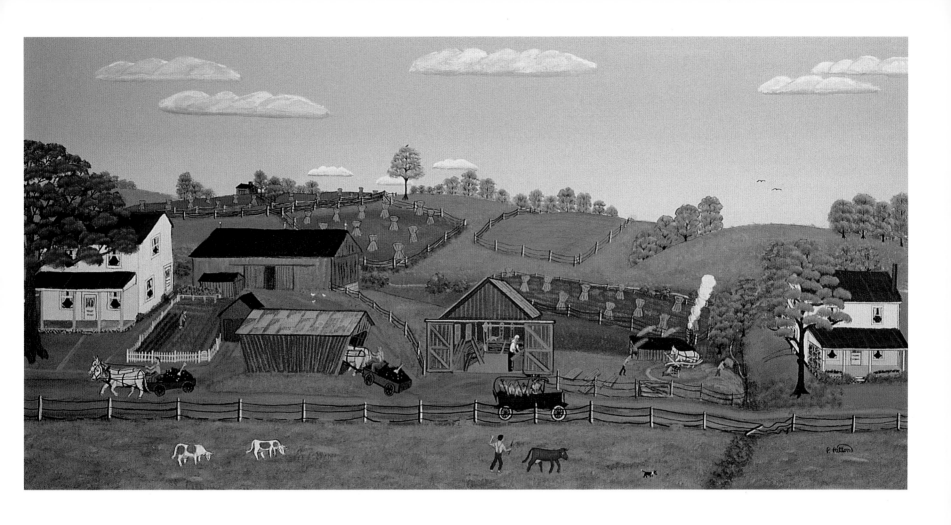

Neighbors on the Claysville Road (1920s). 18" x 36", 1991, #287. Courtesy of University Hospitals of Cleveland.

The Coal Bank

Abandoned coal banks were plentiful in the countryside around Rix Mills, but our neighbor Emery Watson had the only operating one when I was growing up. It was on the Claysville Road, just beyond our house, and the platform scale that weighed the loads of coal was by Emery's house.

I knew of six abandoned coal banks from roaming the woods picking berries and hunting. One of them began on our pig lot and tunneled under our house. Curious, I once crept into Emery's mine. The tunnel was black and silent. Icy water dripped on me from the ceiling. I retreated when my dog Rags refused to follow me.

For awhile Emery hired the two Nelson brothers to dig the coal. They were small wiry men with faces perpetually blackened from the coal dust. They had come to Rix Mills from West Virginia to escape the bloodshed of the miners' labor struggles there. The brothers were typical of men who passed through the area and were willing to chance the shaky beams of the mine. With their miners' lamps on their caps, they went deep into the hillside to dig the coal with picks. They shoveled it into a little coal car which they pushed by hand on rails that led out of the mine onto the loading platform.

The Nelsons lived in a small house outside the village and came into town only for essential groceries and carbide for their miners' caps. We never got to know them; they were in the village for a few years, and then they left as quietly as they had come.

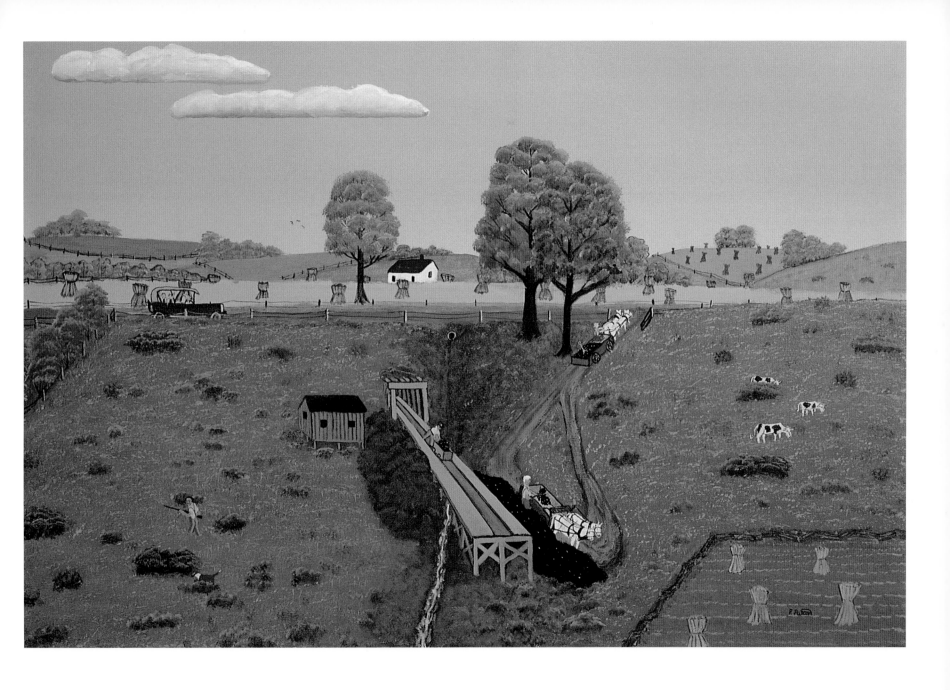

The Last Coal Bank. 20" x 30", 1991, #288. Courtesy of Wendy Patton (Garrity).

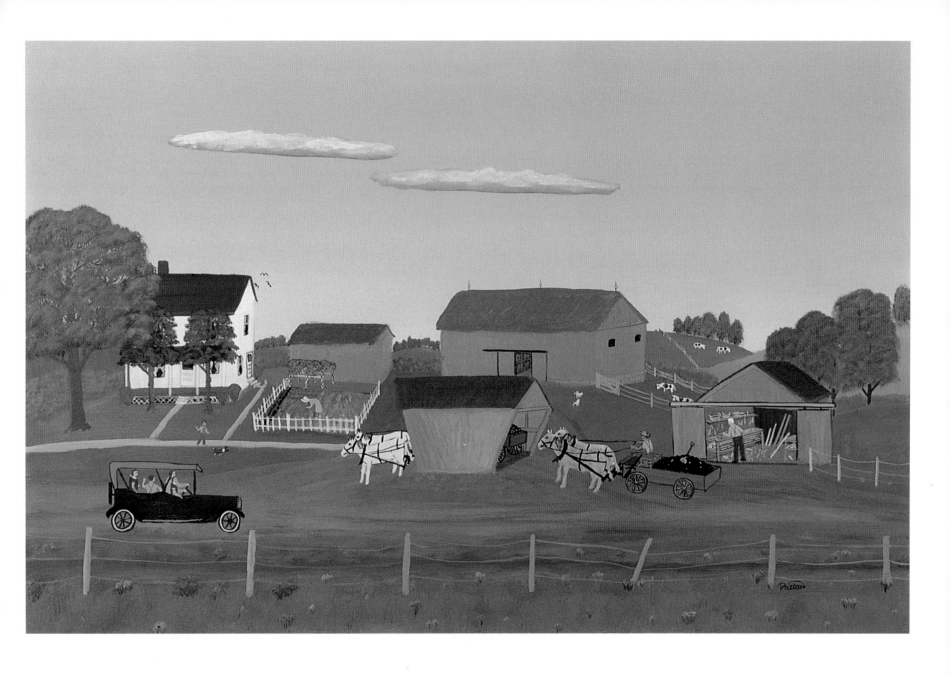

The Coal Scale and Carpenter Shop. 16" x 24" on masonite, 1989, #169. Courtesy of Joseph Van Reeth.

The Sorghum Mill

Joe Grimes's sorghum mill was just across the gully by the side of our house on Emery Watson's property. For most of the year the mill lay silent and neglected behind our quince bushes and sickle pear tree. But by late October or November, our pears were spiced, our quince jellied, and it was sorghum molasses time.

Most farmers around Rix Mills raised a small patch of sorghum for the sweet sap. They brought their wagon loads of sorghum stalks and piled them on wooden pallets beside the mill, or press. Below the mill stood an evaporator shed. Each farmer, in turn, would feed the stalks into the press, while a son or daughter pitched the crushed stalks over the bank onto the stalk pile in our gully.

Joe's horse, Molly, was hitched to the long sweep arm of the press. Molly walked round and round the press, furnishing the one-horse power needed to grind the sweet sap from the sorghum stalks. The sap trickled down a pipe to the evaporator shed. There, in giant pans on long red-hot ovens, the sap was boiled down into sticky, sweet brown molasses.

From the early morning "Giddap Molly!" to the "Whoa Molly!" at dusk, the noise and smoke and steam from the mill were part of our life for a few weeks. After school we watched Joe as he stirred and skimmed the boiling sap in the steamy evaporator shed. On the day when he closed the mill for the year, Joe would give us two half-gallon glass-topped mason jars of molasses. We used the sorghum as a sweetener for boiled breakfast cereal, which I didn't care for, and for ginger cookies, which I liked, and for winter evening taffy pulls, which were great fun.

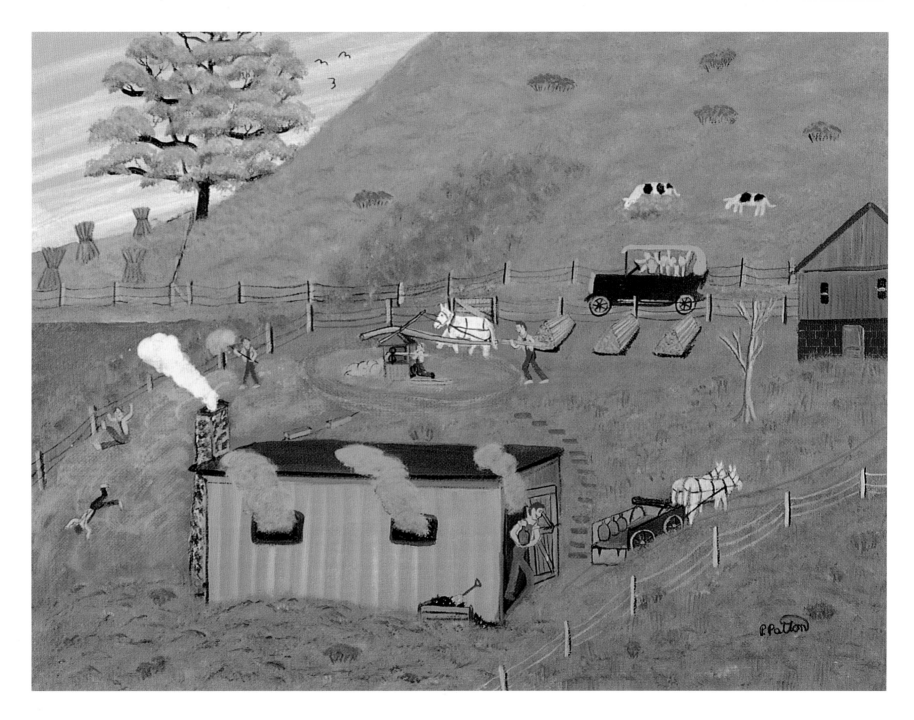

Sorghum Molasses Time. 14" x 18" on canvasboard, 1991, #270. Courtesy of Margaret and Richard Wenstrup.

The Rix Mills Church

Just beyond Emery Watson's house, the Claysville Road joined Rix Mills Road. Around the corner the Rix Mills Church, the parsonage, and the general store stood at one end of the village. Further down the road the blacksmith shop and the school anchored the other. Between and around them, the other houses and buildings in the village clustered along both sides of the road.

In the 1920s and 1930s Rix Mills was fairly isolated. We depended on our own wits and energy for our living, the Watkins man's medicine and our neighbors for illnesses, and our doctor's book for emergencies. The church was the mainstay of the community. It truly gave comfort to the afflicted. It was needed and well attended.

The Sabbath was kept well in Rix Mills. Every Sunday morning my five brothers and sisters and I accompanied our mother to church. Our family pew was in the back of the church, next to a window. I remember sitting through long sermons on hot summer Sabbaths, itching and squirming in my wool Sunday-best, third-hand suit and wearing shoes that pinched. If the window was open, sometimes it was easy to doze off in the warm sunlight. The low buzz of a bee or wasp slipping in got more attention than the preacher.

A short intermission came after the church service, and I liked this best of all. It was time to visit with farm friends and relatives we had not seen all week and to hear news and gossip. Long sermons made us thirsty, and during intermission boys ran across the road to J. W. Lyons's

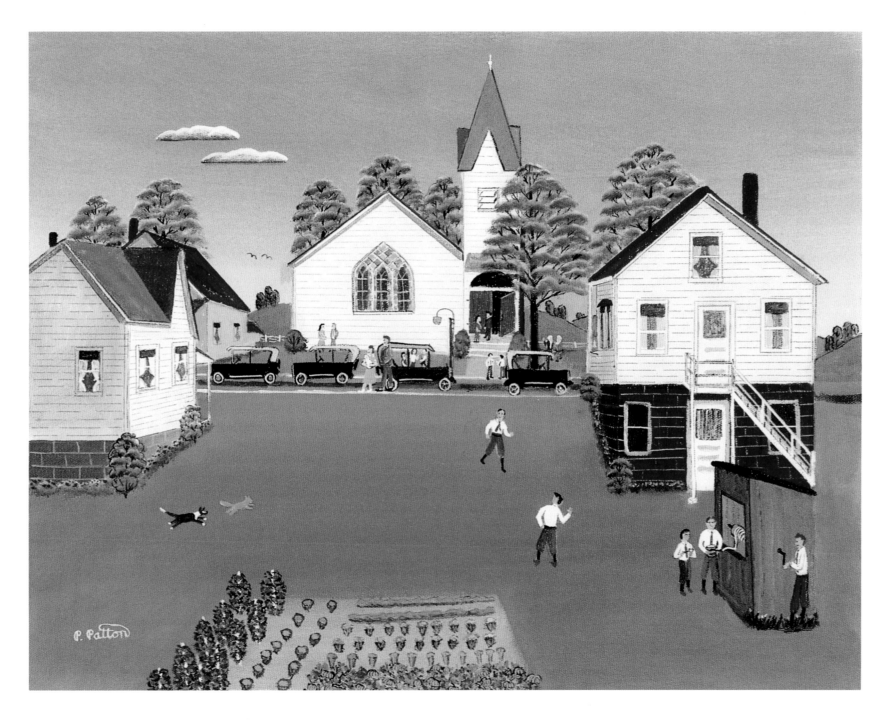

Long Sermons Made Us Thirsty. 16" x 20", 1994, #430. Courtesy of William Benish, M.D.

well in back of his house for a drink of water. After inter-
mission a few people drifted away, but most of us went
back to church for Sabbath school classes in Bible study.

We went home to the biggest and best meal of the
week. Sunday dinner was often one of our own chick-
ens. After dinner, rest was the order of the day. We
could sleep or take a walk or read, but not the comics.
There was no work other than necessary chores, like
milking, and there was certainly no play. After a light
supper, often bread and milk, young people went back
to church for Sabbath evening services.

Most everybody in Rix Mills went to church, but not
everybody. Some, particularly some men, just gave up
on formal church-going religion. I don't remember
ever seeing Joe Grimes or Emery Watson there. Some
showed up for Easter services, and we were glad to see
them. And they all came to church for funerals. But we
just never saw them at Sunday-morning services or at
Wednesday-evening prayer meetings. These were good
friends and neighbors, and we accepted the fact that
they listened to a different drummer.

The Different Drummer. 16" x 30", 1992, #304. Courtesy of Sharon Schnall and R. Drew Sellers.

The Glass Cat

Our preacher was Reverend William Glass. The Glass family lived in the parsonage beside the church. There were as many Glasses living at home as there were Pattons, and they were a welcome addition when they came to Rix Mills from Nebraska. They joined us in church, school, and in life. Through marriage they are related to many of us now. Joe Glass, the youngest of the family, was my childhood playmate and is in many of my paintings.

The Glass Cat is a village scene typical of a nice fall Saturday morning in Rix Mills in the early 1930s. In the painting, John Barnett and Warney Young are loafing at the store porch. Taylor Bowen, the blacksmith, is holding the door of the store for Agnes Moorehead, who has come from New York City to visit her grandparents, Robert and Hannah Moorehead. My brother Ralph and Dalton Tom are repairing their cars. Dalton is underneath the car calling for a wrench, but Ralph is watching the cat activity. Joe Glass is about to go out on the porch roof to get the cat. Irene Glass is coming out to see the commotion. Florabelle Glass is ignoring everyone but Boyd Patton, who is waving from the coal wagon passing by.

The little white two-room building by the store served as a traveling doctor's office many years ago. In time it became mine, and it eventually ended up as part of a little house I built off the campus of Muskingum College in New Concord after I returned from World War II.

The Glass family's neighbors across the road from the parsonage were Mayn (Maynard) Forsythe, with a big shock of white hair, and his wife, Lizzie; my Aunt Ada and her husband, Johnny Campbell Watson; and J. W. and Sadie Lyons. J. W. was the village carpenter. As the church custodian, he lit the gas chandeliers inside the church when they were needed, built the fire in the church's basement furnace, took care of the church building and churchyard, and lit the village's one street light, the gas lamp out by the road in front of the church.

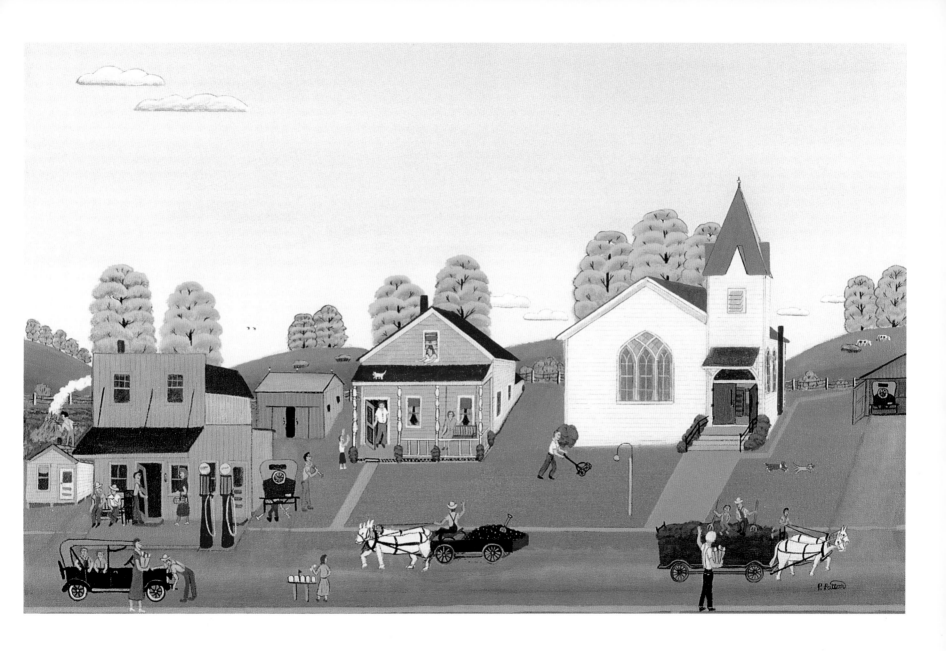

The Glass Cat. 20" x 30" on canvasboard, 1992, #324. Courtesy of Joseph Glass.

The General Store

In the very early 1920s, Rix Mills still had three stores: the Ledman-Watson store sold groceries; Billy Barnett's store sold hardware, feeds, and farm equipment; Billy Messick sold clothing and dry goods. When Billy Barnett's and Billy Messick's stores closed, Jim Ledman and Johnny Campbell Watson took over their inventories.

This is the merchandise listed on the Ledman-Watson general store stationery in the 1920s: groceries, Queensware (china, I imagine), dry goods, gents' furnishings, shoes and rubbers, hardware, paints and oils, drugs and medicine, books and stationery, auto tires and sundries, as well as butter, eggs, poultry, seeds, hides, and wool. Whatever we needed the Ledman-Watson general store probably had.

The old store, with its rectangular facade in front, was already silvered with age when I was a boy. A hitching rail and two gas pumps (hand operated), one for regular and the other for high-test, stood by the road in front of the store. In back of the store was a barn.

On a cold winter night when the roads were good enough to get to town, the benches around the store's potbelly stove were filled with loafing farmers. On summer evenings farmers gathered in town on the store's concrete porch to smoke their pipes and swap news. Postage stamps were bought at the store and letters deposited in the mailbox on the porch.

Jim Ledman and Johnny Campbell Watson were the store's proprietors. Johnny Campbell Watson was my uncle, my Aunt Ada's husband; they lived across the road from the store. Jim Ledman lived down the road beside the school. They opened the store any time, just for the asking. The store opened when the first farmer came to town. It closed when the last farmer left the store, which might be nine or ten o'clock at night.

The store had a truck that Bill Barnett was hired to drive on rural routes in Rich Hill Township. Each week he loaded the Reo with orders telephoned in, as well as staples, and drove from farm to farm making sales and buying eggs, butter, and chickens, which he sold in Zanesville on Friday.

The countryside was considerably less isolated once we got telephone service. I remember when we first got a telephone. Alma Watson operated the switchboard in her home, across from the blacksmith shop. The farmers' exchange telephone system tried to keep up with the need for telephone poles and for the blue clear glass insulators necessary for stringing the lines. With weather and rot ruining the poles, and boys practicing marksmanship with .22 caliber rifles aimed at glass insulators, lines sometimes wandered along the countryside on fenceposts. I don't know if the store had a party line or not, but the rest of us did.

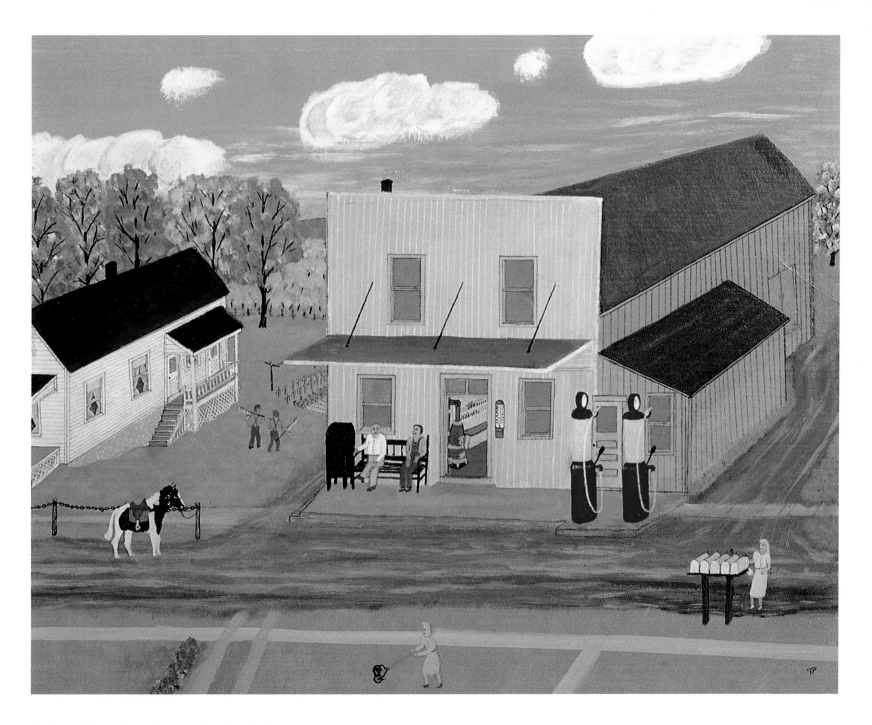

The General Store. 16" x 20" on canvasboard, 1986, #9.

Saturday at the General Store

On Saturday, when farm families came to town, wives sold their eggs and did their buying at the store. When the buying was settled, either cash or credit, the children got penny suckers. Nearly everyone was short of cash by spring, and credit at the Ledman-Watson general store was a lifesaver.

The floor of the old store sloped down past the potbelly stove in front to the main serving counter in the back. Jim Ledman generally stood behind the counter, a tall man in a rumpled white shirt, his arms on the counter. Jim was a reassuring, substantial presence. And Johnny Campbell Watson, the co-owner, was a favorite with the boys. The counter held scales and a glass case for a wheel of cheese. Barrels of sugar, flour, beans, and coffee were stored under the counter, and beneath it was a shelf where the wooden money drawer was kept, and in it the scratch-pad tallies of family credit. The store walls were lined with shelves stocked with cans, jars, bottles, bolts of cloth, and more. A counter on each side of the store faced these walls.

Behind the main counter a rope, pulley, and a counterweight helped open a trapdoor to the basement, where wheels of cheese, bologna, bags of potatoes, eggs, and other perishable foods, as well as soda pop, were kept cool. An unheated back room of the store held hundred-pound gunny sacks of animal feed, a platform scale, hardware, and a large storage tank of coal oil with a hand pump on top for farm lamps and lanterns. A side room of the store held overalls, men's shoes, a shoe repair bench, and motor oil.

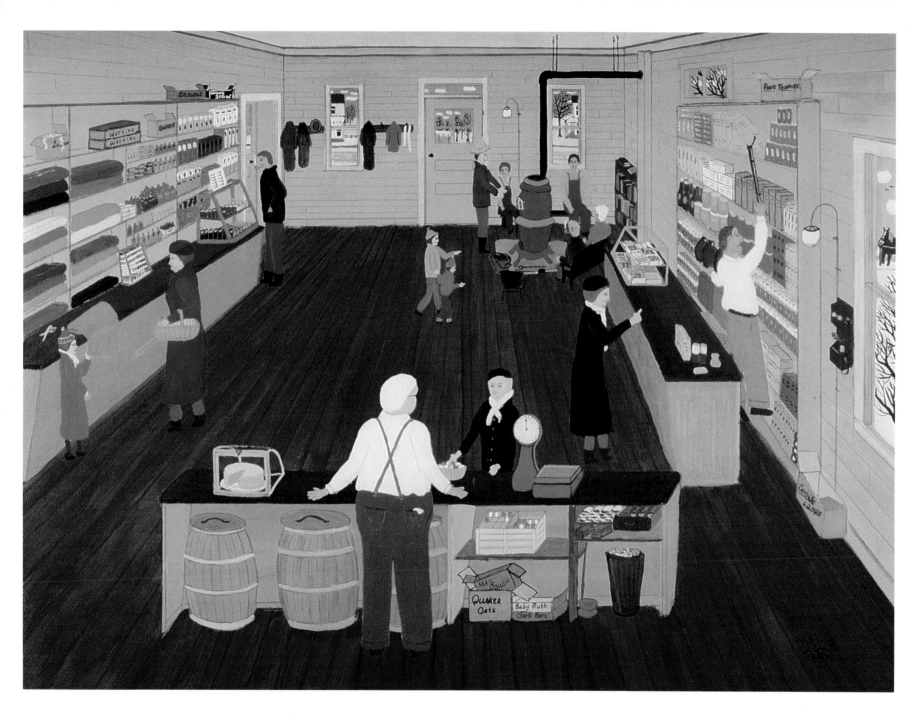

Saturday at the General Store. 18" x 24" on masonite, 1988, #82. Courtesy of Dorothy Abbott Patton.

The School and the Blacksmith Shop

The other end of the village along the Rix Mills Road was anchored by the school and the blacksmith shop. The blacksmith shop was a regular stopping place for boys on their way to and from school. In the 1920s farmers in Rich Hill Township still had horses in need of shoes, harnesses that needed mending, and wagons and buggies to be repaired. They brought them to the Rix Mills blacksmith shop.

Warney Young's blacksmith shop was nothing more than a substantial shed with an earthen floor and a glowing forge inside. I can still hear the blows of the heavy hammer on the iron, see the sparks fly from the anvil, and see the fire rise as I pumped the bellows at the fireplace.

Warney was an old man then. He lived next door to the shop, and his blacksmith was Taylor Bowen. Warney sat in a ripped and stained old wingback chair close to the hearth and offered advice to Taylor. It was Warney who showed me how to breathe life in the fire by pumping the bellows. But it was Taylor who made the anvil ring as he hammered red-hot iron into shape. A stocky man with curly black hair, Taylor Bowen was my brother Ralph's village hero.

I remember the day Taylor's tools were sold at auction and the blacksmith shop was closed. I was seven, with a dime to spend, and I sat on the earthen floor between the legs of my Uncle Perl Elliott. I bid ten cents on each tool as it was auctioned. At last the auctioneer called "Sold!" to my bid, and I got a basket of old tools, including a broken leather punch (which I still have and use occasionally).

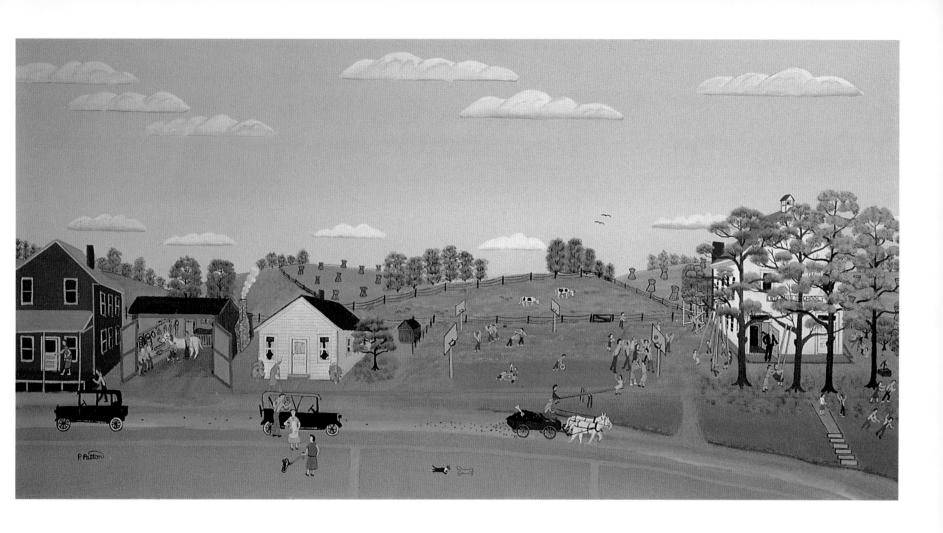

The School and Blacksmith Shop. 18" x 36", 1991, #286. Courtesy of University Hospitals of Cleveland.

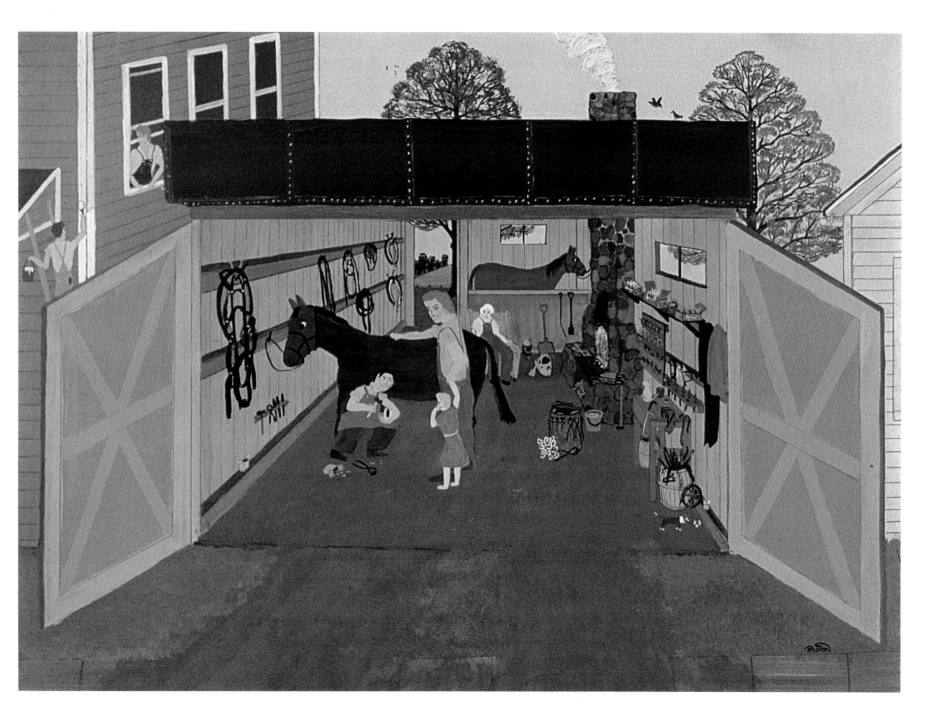

The Blacksmith Shop. 18" x 24" on masonite, 1988, #101. Courtesy of Irving Rothchild, M.D.

The Rix Mills School

At the edge of the village, the Rix Mills school was a big old two-story, white clapboard building with a belfry. The first-floor classroom was the grade school; the second-floor classroom above was a two-year high school.

The grade school had eight rows of desks, one for each grade. The first grade was close to the big coal furnace in the corner of the room, so those pupils were warm in winter. The eighth grade sat close to the cloakroom, where they were sent when they misbehaved.

The desks were graduated in size to accommodate growth as the pupils progressed through the grades. Occasionally a pupil came along who just couldn't "pass," and he (generally a boy) would be held back until he outgrew his desk.

Vernon Monroe, a farmer in the summer, was our teacher in the grade school. He was six-foot-four-inches tall, the tallest man in the village. Mr. Monroe rang the school bell by tugging at a rope threaded down through holes in the ceiling of the entry hall. We all knew that if you yanked too hard on the rope, the bell would flip over and be out of commission until someone climbed to the belfry and flipped it back over. This happened each Halloween, as well as at other times.

Students who finished the two-year high school had to go to Rich Hill, Chandlersville, or New Concord high school to graduate. Marion walked the three miles to Rich Hill, Carol rode there with a teacher, and Robert was taken to Cambridge by Harry Kirk to live with his family and play football for the high school. The Rix Mills two-year high school was closed when Ralph, Dorothy, and I were ready for high school, so we rode the school bus to New Concord High School. I graduated in 1939, along with classmate John Glenn.

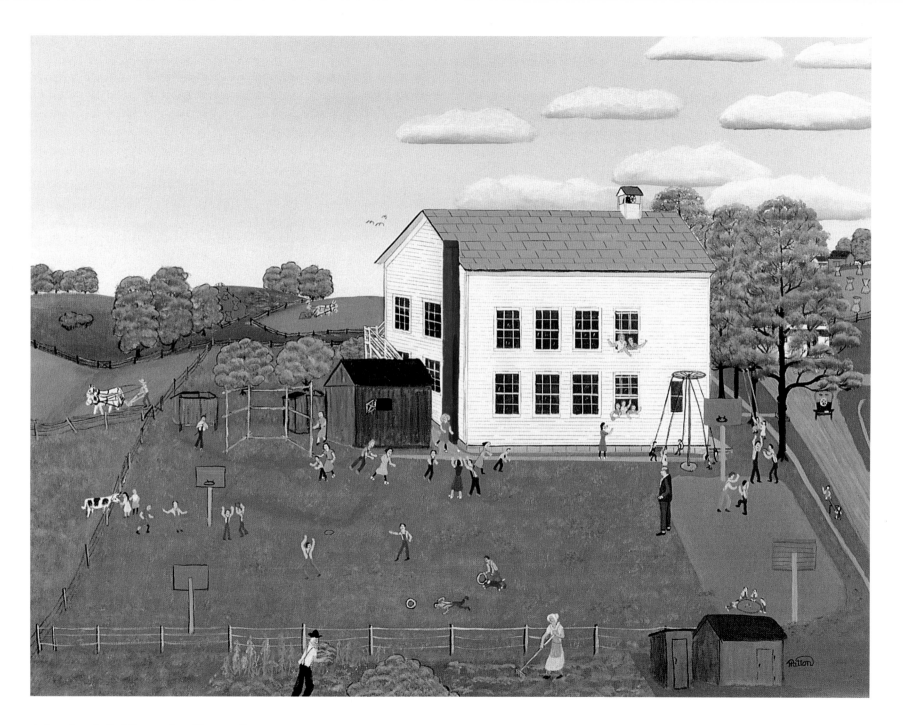

Anthony Over the Coal House. 22" x 28", 1990, #202.

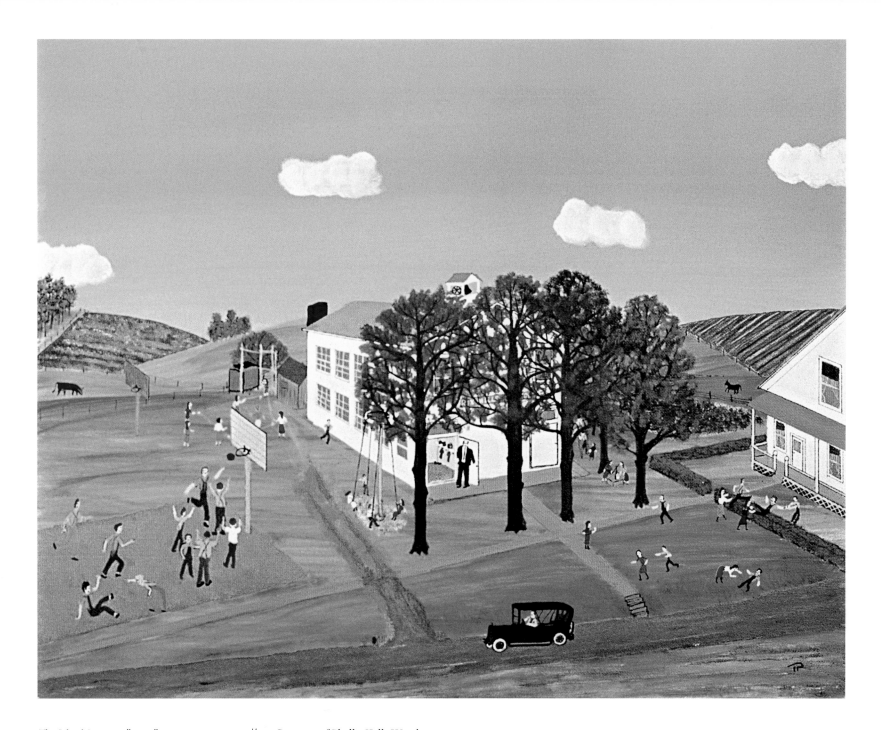

The School Recess. 16" x 20" on masonite, 1986, #28. Courtesy of Phyllis Kelly Woods.

The School Janitors

I was the last of the six Pattons in our family to have the job of school janitor. From fifth grade through eighth grade I was the grade school janitor. The job paid well in those days: I got five dollars a month, enough to buy my clothes and a bicycle.

My sister Marion, oldest in the family, had the job first, when she was twelve and when the family moved back to Rix Mills after my father's death. For the next fourteen years one of us, in turn, was either the grade school or two-year high school classroom janitor. In September my mother, five brothers and sisters, and I spent a day washing windows and cleaning the school before it opened.

The school janitor washed the chalkboards daily, cleaned the erasers, swept the floor, dusted once a week, cleaned the water jug in the cloak room (a job I sadly neglected), wound the clock, and helped Mr. Monroe oil the floor boards in the middle of the winter. But our most important job was building the fire in the big classroom stove in the winter, early in the morning, long before school began.

When I finished eighth grade, Joe Glass took over the job.

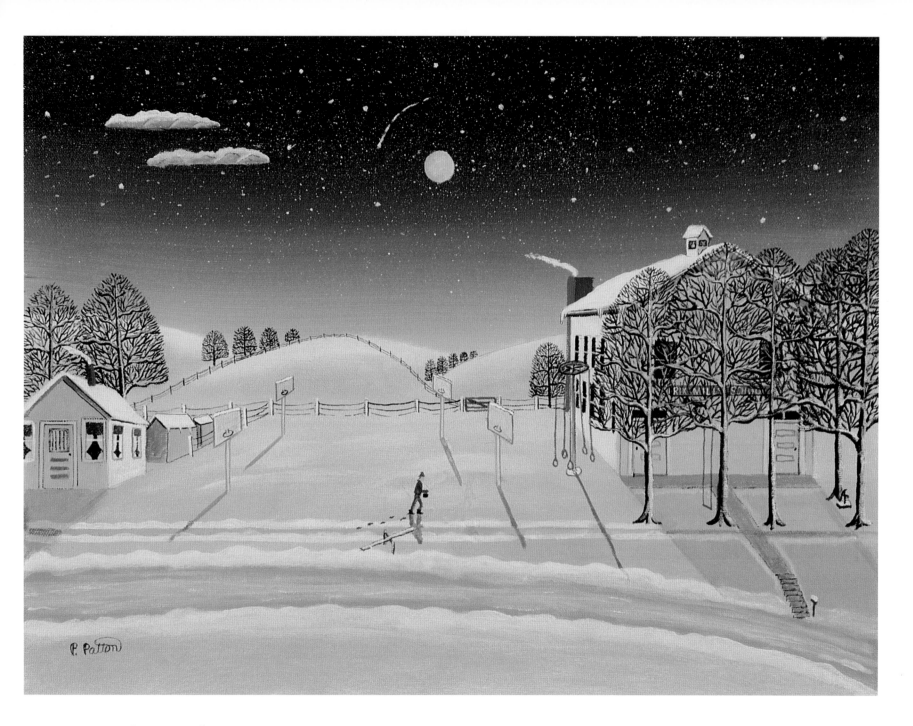

The Schoolboy Janitor. 14" x 18", 1996, #506. Courtesy of Karen Kane.

Spring and Summer in the Village

Flying Kites

In the country our lives moved with the rhythm of the seasons. Winter was a time to survive, for us as well as the creatures in the fields. When winter snows gave up their grip in the face of March winds, April days of sun and showers brought a surge of life to the hills and valleys. When the snows finally melted, the land turned green and the countryside blossomed. Even the roosters sensed the change and crowed with joy. Spring's reconciliation of man and nature was under way.

Sometimes even before the snow had melted, we climbed the hill to fly kites. For ten cents we could buy a paper and balsa wood kite made in China and a ball of string from the general store. To guide the kite up, we made kite tails from the ragbag and lengthened or shortened them as needed according to the strength of the wind.

When we finally attached the kite, tail, and string, we played out about thirty or forty feet of string. A friend tossed the kite up in the air, and we ran against the wind, dragging the kite in the air. It wobbled and dived but gradually climbed toward the blue sky. Then we had a direct connection to Heaven.

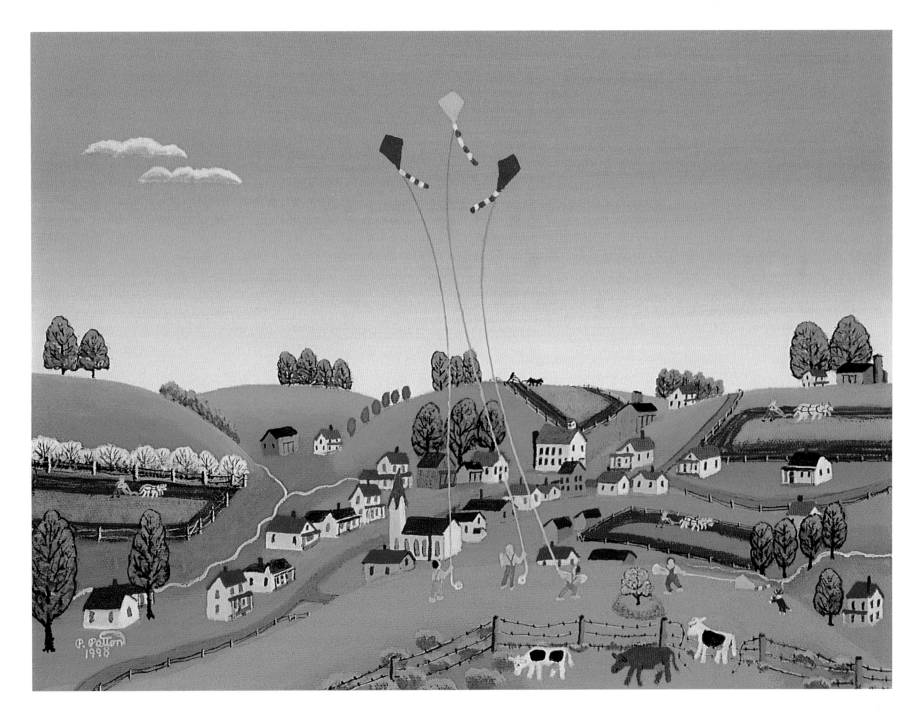

Flying Kites. 11" x 14", 1998, #550. Courtesy of Emily Anne Ehrhart.

Flying Kites. 18" x 14", 1995, #487. Courtesy of Charles V. M. Fink.

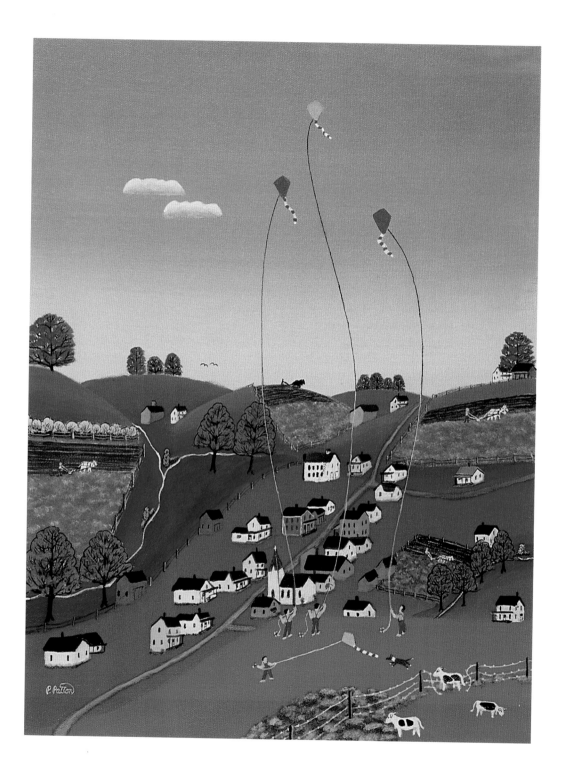

Spring Plowing. 16" x 20", 1993, #374.

Spring Planting

When April and May came, the snow and ice finally melted and the countryside blossomed. When the fields were dry enough, farmers hitched their teams of horses to the plow and worked the land from dawn to dusk, cutting clean straight furrows. Walking behind the horses and guiding the plow, the men were jerked and jolted as limestone rocks worked their way to the surface of the soil.

In town and on the farms around, everyone planted a garden. We ate out of the garden all summer and put away its plenty for the winter ahead. In early May Uncle Perl Elliott plowed our garden. It was a large garden with plenty of room for all the vegetables we wanted—and some we didn't want but which my mother thought would be good for us. After the plowing was finished, the rich black soil was ready for the sharp steel wheels of the disc, which broke the clods of earth into a fine seed bed.

My mother had been preparing for planting long before the garden was plowed. Most of the seeds she got at the general store, but some were bought mail-order from the Burpee seed catalog, and Aunt Ada had started cabbage and tomato plants for us in her cold frame when April nights were still frosty.

When I was old enough to help with planting, this was a spring ritual I loved: digging the rows with a hoe as straight as possible, dropping the right number of

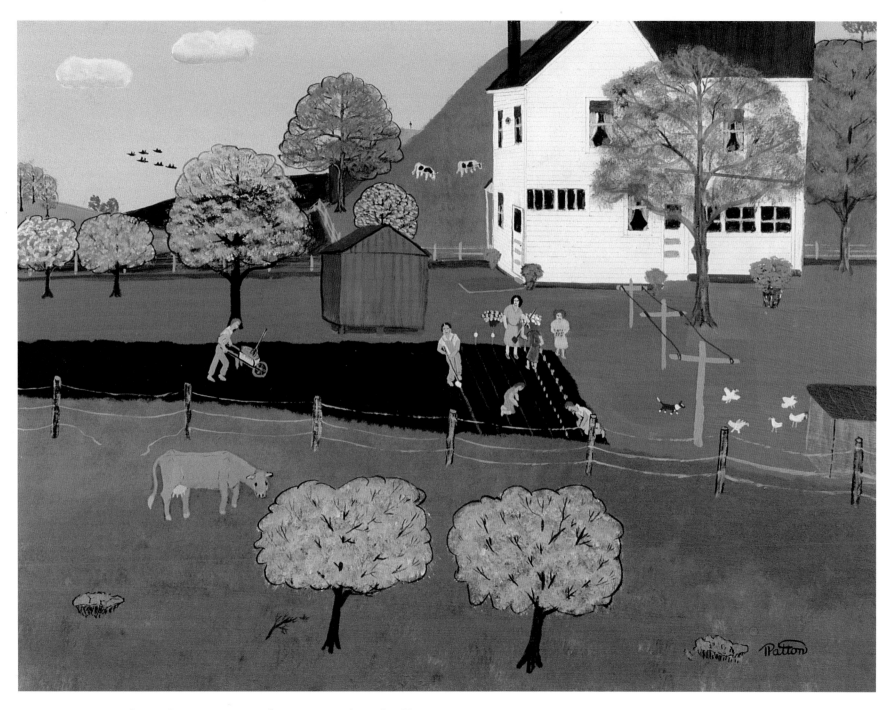

Planting the Garden. 13¾" x 17⅝" on masonite, 1989, #138. Courtesy of Dorothy Abbott Patton.

tiny seeds for each hill or plant, getting the soil firm around the spindly young tomato plants—all actions I still rehearse with pleasure after a half-century and more have passed since I last planted our garden.

The weather was crucial during spring planting weeks. Sometimes the rains continued too long, keeping farmers from their fields. Spring drought, too, was always a threat. Somehow farmers and their families survived, sometimes with the help of the wife's butter and egg money and with credit at the general store.

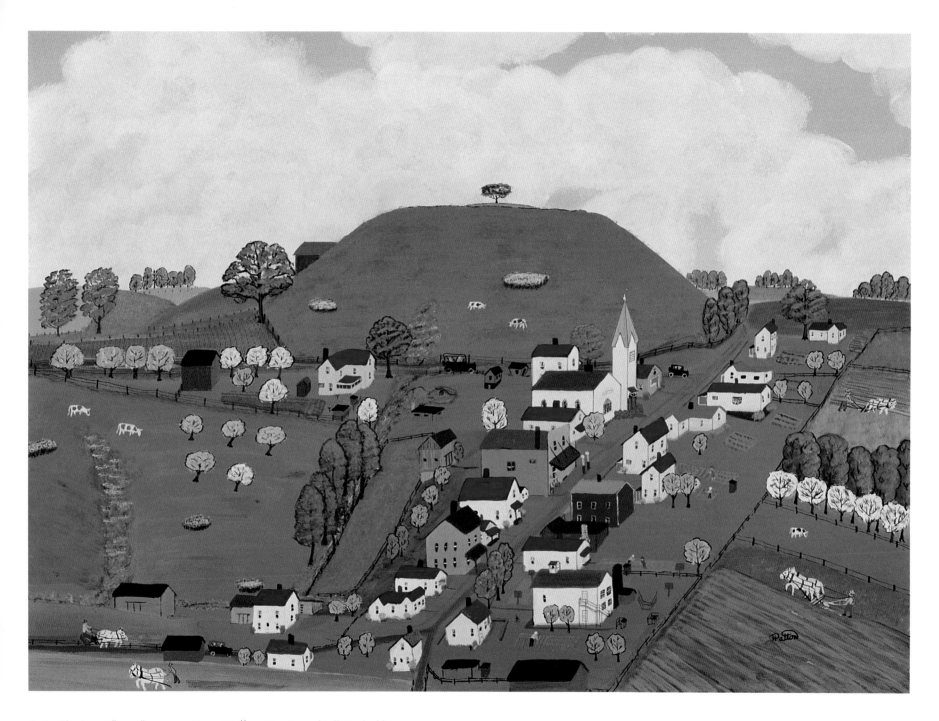

Spring Planting. 18" x 24" on masonite, 1988, #90. Courtesy of Jeff Carskadden.

The Congregational Dinner

Once a year, in the spring, the Rix Mills United Presbyterian Church held its congregational meeting. The meeting was held on Saturday, and most everyone came. A hired speaker from a speakers' agency would lecture during the morning session. He had many funny jokes and inspirational stories for the young and uplifting and hopeful messages for the adults. Then we had the congregational dinner followed by the annual business meeting (where we commented on and hired the minister, elected the elders, and selected the Sabbath school superintendent, church treasurer, and other officers).

Sometimes I missed the morning meeting, and I always avoided the business meeting. But I never missed the congregational dinner.

Heavy plank panels were set on saw horses to form a long table in the back of the church. This table was covered with white butcher paper, and here was spread a country potluck feast of amazing quantity and unmatched quality: great platters of pork tenderloin and pressed chicken sandwiches, baked beans, vegetable casseroles, fruit and vegetable salads, home-baked breads, devil's and angel food cakes, cream and fruit pies, and more, much more . . . all made with the country wife's care and with some feelings of competition. Most everyone came to the congregational dinner.

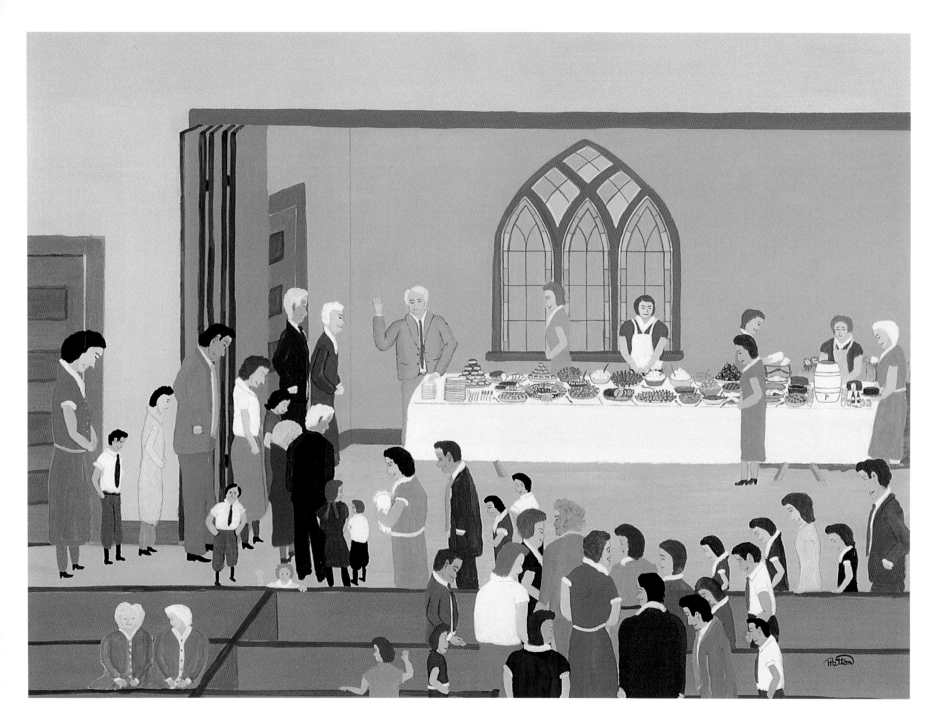

The Blessing (The Congregational Dinner). 18" x 24" on masonite, 1988, #134.

Boarding Out

Summers were work time in the country: hoeing corn, shocking wheat, loading hay, threshing, building fence, painting buildings, and countless other chores in farm life. My five brothers and sisters and I hired out on nearby farms as soon as we were old enough to be helpful. Sometimes we hired out all summer. We earned our keep, board and room, and small wages. We got to spend Sunday at home.

When I was nine an older cousin, Dallas (Spivy) Sims, hired me for the summer to help out on his farm, and I boarded with the Sims family. His mother was my Aunt Maud. I hoed long rows of corn, helped with the milking, slopped pigs, learned to drive the team of horses hitched to the hay wagon, did chores around the farm, and was homesick most of the time.

On Saturday afternoons, when it was time for me to go home for my Sunday holiday, Dallas would give me whatever change he had, never more than a dollar. One week it was thirty-five cents, and that seemed like a fortune to me. When I got to Rix Mills I went straight to the general store and bought seven Powerhouse candy bars and ate them all. Those were the last Powerhouse candy bars I ever ate.

The summer I was thirteen, I hired out at John Crawford's farm. John was the Rix Mills Church Sunday school superintendent, a large, stout man with a loud voice. He paid me a man's wages—a dollar a day—and expected me to do a man's job. I did. Among my jobs I climbed to the top of an extension ladder set up on the hay wagon bed and painted the comb of his barn. I remember a wasp stung me as I slowly and carefully backed down the ladder.

I walked the three miles to the Crawford farm every Sunday afternoon and walked home again every Saturday evening. My day started at 4:30 each morning, when I milked the cows. After a big breakfast with eggs, ham, potatoes, oatmeal or dry cereal with cream and sugar, and always pie or cake, John and I would harness his team for a day's work in the fields.

John's horses were hard to harness and drive. Almost every day John got angry with the horses and hit them with a singletree or a heavy stick. He was so big and strong that he could force them to go where he wanted. They were much stronger than I, and I didn't hit them, so I generally went where the horses wanted to go. One day when I was out in the cornfield with the horses hitched to the cultivator, they plowed out most of two long rows of corn.

In the evening, after the cows had been milked, we washed up at the backyard pump and went in for family prayers. I would sit in the living room with John, Mrs. Crawford, and their teacher daughter who lived at home with them. By the light of the coal oil lamp, John would read us a chapter from the Bible. After that we all knelt at our chairs and John would say a long prayer. Then I was free to go upstairs to bed.

Milk Cans at Sims. 16" x 20", 1994, #439. Courtesy of Anita Sims Allen.

Haying

I was most often hired as a farm hand to help with the haying. All summer long farmers grew clover and alfalfa hay to feed their dairy cattle, horses, perhaps a bull, and the occasional few steers a farmer might keep for beef. Feeding them in the winter took a lot of hay. Three or four times a summer farmers mowed the hay, cured it in the sun for a few days, and then stored it in the barn. Most of the space in a barn was used for storing hay in large mows at both ends of the barn.

My job as a hired hand began when the clean, sweet fragrance of new-mown hay hung in the valleys around Rix Mills. When the sun had cured and partially dried the hay, the hard work of haying began. The hay was raked into long windrows with a horse-drawn hay rake. Next the hay was gathered by pitchfork and piled into hay shocks, ready for loading on the hay wagon to take to the barn and fill the mows.

Driving the team that pulled the big, flat hay wagon was often the first job handled by a young boy. An older boy standing on the wagon might distribute the hay as it was pitched up on the wagon by yet older boys and men. The wagon, loaded high with hay, was pulled by the team to the barn, close under the hay window, beneath the comb of the barn.

At that point one horse was unhitched from the wagon and hitched to the hay rope. This rope ran through several pulleys to a track clear at the top of the barn that guided a two-pronged hayfork which was plunged into the hay on the wagon and anchored there by trip prongs.

The unhitched hay rope horse was always ridden by the youngest boy. As he rode the horse away from the barn, the loaded hayfork rose up the side of the barn into the hay window along the track to the proper hay-mow. When the man in the barn haymow shouted, the trip rope was pulled to release the hay from the fork, to be mowed back by the oldest boys and men. Then the youngest boy rode the hay rope horse back toward the barn, and the hayfork dropped down outside the hay window to the hay wagon.

I learned to drive the team and to guide the hay rope horse when I was nine and at Dallas Sims's. When I was ten I started shocking hay, building the loads on the wagon, and setting the hayfork for Morris White and Billy Copeland. When I was thirteen I was pitching hay and mowing back for John Crawford. I can remember helping with haying for Mark Moorehead, my Uncle Perl Elliott, and Joe Grimes.

Farm families were large, generally with six to eight children, and farmers usually had enough sons to help with the haying. The only time that so many men and boys shown in the painting would be seen haying was when a farmer was ill or injured. Then three or four neighbors would bring their teams and sons and handle haying in one day.

Haying. 18" x 24" on masonite, 1987, #53. Courtesy of Dale and Nancy Shepherd.

Wheat Harvest

Sometime in July the wheat matured and was ready for harvesting. When it was golden ripe, the farmer had a relatively short period of time for cutting and sheaving the grain with the binder. Then he stacked the sheaves into shocks for threshing. If he waited too long the wheat was subject to wind damage, or the straw stalks might break under the weight of the grains in the head.

No Rich Hill Township farmer in the 1920s or 1930s had a combine that would mow and thresh the wheat in one mechanized process. But most farmers did own a binder, and with that, together with a team of horses and the help of a couple of sons, they handled the harvest.

As a hired hand I often helped with the wheat harvest. That was my place in the food chain. I never drove the binder, which required much practice and skill in horse handling. But between my tenth and seventeenth year, under a blazing sun in a clear blue sky, I stacked what seems like thousands of wheat shocks.

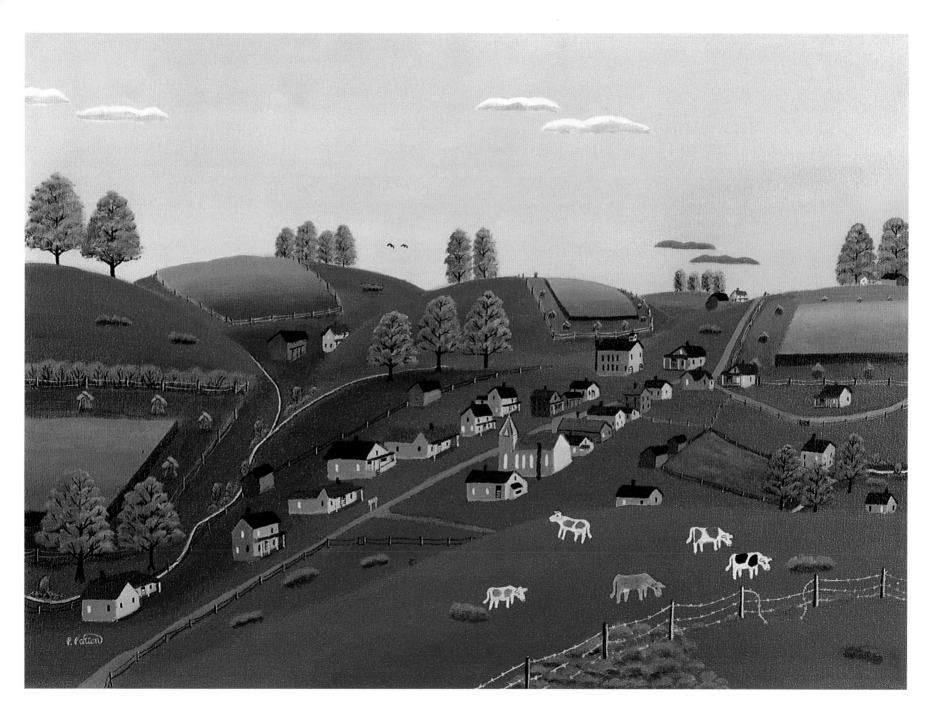

Wheat Harvest Time. 18" x 24", 1996, #492. Courtesy of Karen Kane.

Threshing at Mooreheads

One summer in the 1930s when I couldn't find a job on a farm, Hop Miller hired me to help with his threshing crew. I "backwired" on the baler—a job that covered me with chaff, was responsible for numerous chores and errands, and found me sitting at the threshers' dinner table. I earned a quarter a day if it didn't rain.

Hop had the tractor, threshing machine, and baler farmers in Rich Hill Township needed to harvest their wheat and oats in July. With Hop's old tractor pulling the monster threshing machine and stationary baler, we lumbered from farm to farm in clouds of dust and chaff, threshing the grain.

Sometime in July the wheat matured and was ready for harvesting. The farmer and his sons would cut and sheave the grain with the binder and stack the sheaves into shocks. Then at threshing time neighboring farmers shared labor and brought their sons and wagons to help haul the grain from the fields to the threshing machine. By the time Hop had his tractor and threshing machine lined up and belted, the wagons were waiting, loaded high with golden sheaves.

Hop would throw the lever, the long drive belt would slap to life, and the wheels and gears and fans would shudder into what seemed utter chaos. The farmer on the wagon first in line would start pitching sheaves on to the thresher conveyer belt and "thrashing" was under way.

We ate prodigious dinners at each farm's threshers' table. These feasts were shared efforts, too, by the farmers' wives and daughters. I gained twenty pounds and must have grown five inches that summer.

The Moorehead farm was one of the few around Rix Mills that the power company could not buy for stripping twenty or thirty years later. The famous actress Agnes Moorehead inherited her grandparents' farm, and she could afford to refuse the price offered for the farm. She hired Harry Forsythe as her tenant farmer and renovated the farmhouse. The house stands a half-mile east of Rix Mills on the Claysville Road, now Route 313.

In her retirement, the actress built a house in the woods on the property. Aunt Ada, who made draperies for a Zanesville department store, in her eighties made drapes for the house. Agnes Moorehead was often in Rix Mills when she attended Muskingum College, and she made regular visits back during her rise to stardom as a character actress in movies, radio, and television.

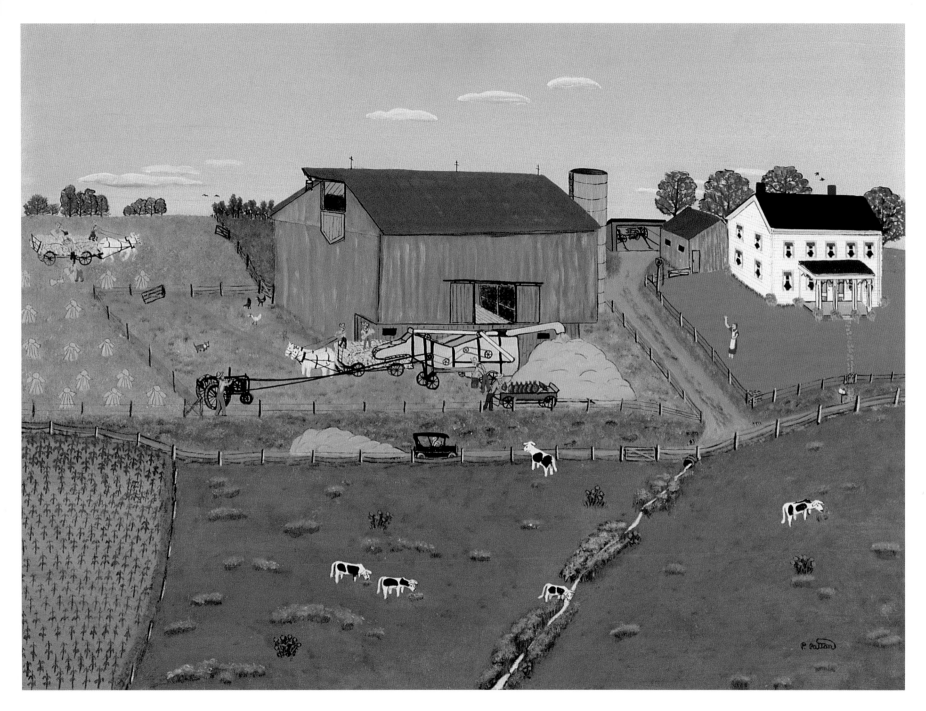

Threshing at Mooreheads. 18" x 24" on masonite, 1987, #38. Courtesy of John Ong.

Mending Fence

By the 1920s rail fences from earlier times were falling in disrepair. Some hedge fences were planted, but generally replacement fences were barbed wire strung between hedge posts. Mending fence was a never-ending chore. The farmer bought his spool of barbed wire at the Ledman-Watson general store, loaded it in his wagon with posts, posthole diggers, block and tackle, and a son or two and built the fences that kept his stock from his crops.

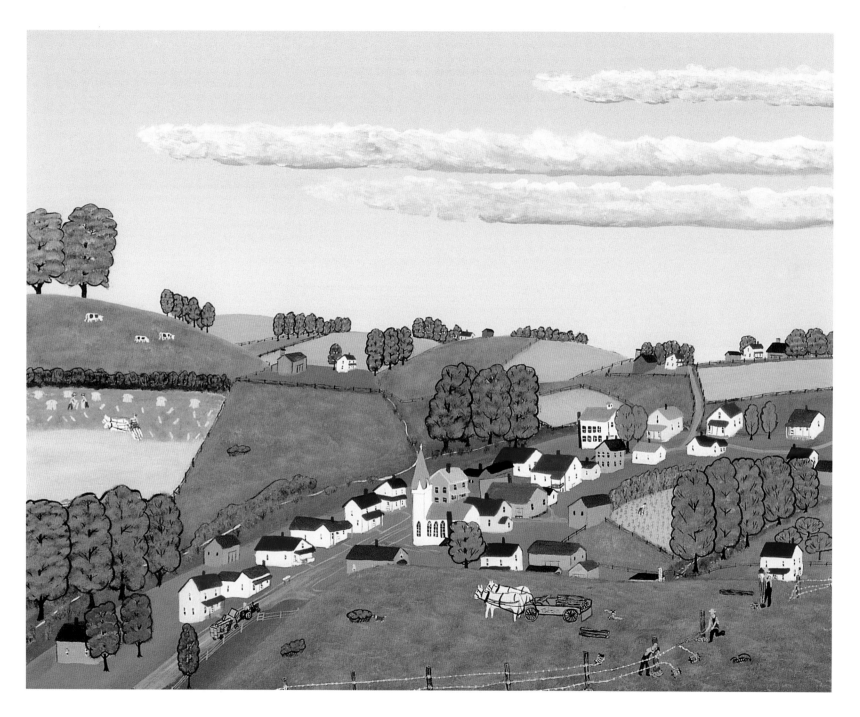

Mending Fence. 22" x 28" on masonite, 1989, #162. Courtesy of Rush Henry Ehrhart.

Cutting Corn

Billy Copeland's farm lay just over Ben St. Clair's Hill. I worked for Billy in the summer sixty years ago, and I remember as if it were yesterday walking across the field to the house for a cold drink of water or, at noon, lunch. But I never helped Billy with cutting corn because I was always in school at that time of year.

Corn to feed farm animals was allowed to mature and dry, standing in the field until middle or late November. Then Billy and the other farmers around Rix Mills would sharpen their corn knives' two-foot blades and head for the corn field.

They walked methodically down the rows, slightly bent, slashing cleanly through each corn stalk leaving about six inches of stubble. As the farmer cut, he collected the stalks, tied them in an armful, and shocked them together. Then he could husk the corn later in the field or haul it to the barn to husk on bitter, blustery winter days.

Billy was a bachelor, a short, slight man with a kind of precise way of talking. He was extremely shy. For awhile Billy had a saddle horse, and he would saddle up and ride the eighth of a mile to church on Sunday. He lived with his aging parents, worked hard, and kept to himself.

I remember one summer day when Emery Watson and I helped Billy shock wheat. Emery seemed like an old man to me then, in eighth grade, but he was so skillful I couldn't keep up with him, and I know now he wasn't really old.

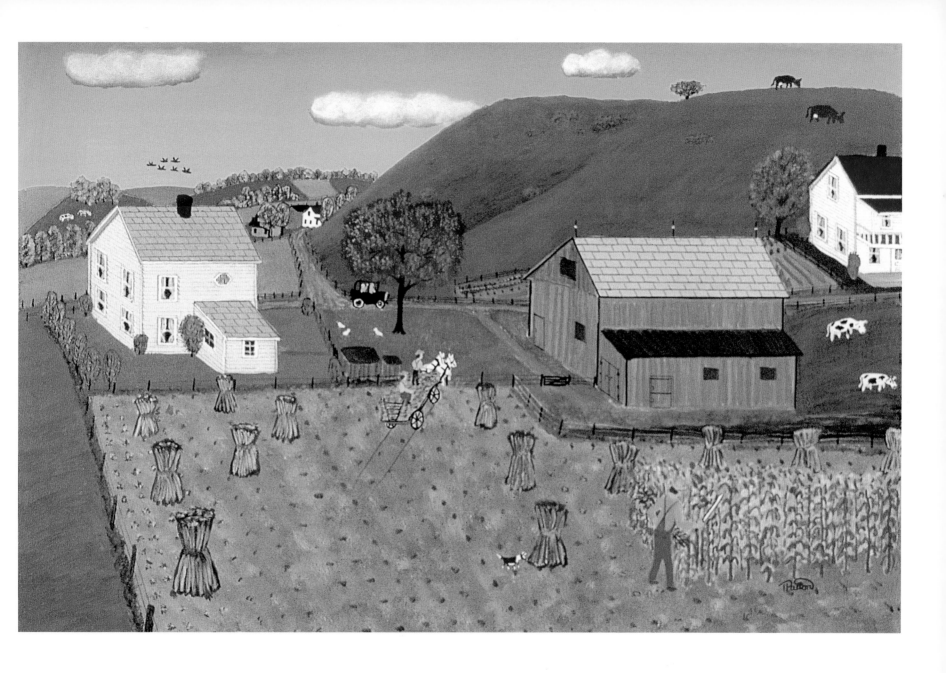

Cutting Corn. 12" x 18" on masonite, 1987, #74. Courtesy of Wendy Patton (Garrity).

Wils Patton's Farm

One summer in the early 1930s when none of the farmers around Rix Mills had money for a hired hand, I got part-time work for J. W. Lyons, the church custodian, mowing the grass at Salt Creek Cemetery. I got the worst case of poison ivy I ever had when I clipped the grass and vines at the edge of the graves.

Across the road (now Rt. 313) I could see Wils (Wilson) Patton's farm spread below me in a deep valley and beyond the rooftops of Rix Mills. Wils's farm was a mile from Rix Mills down the lower road to Chandlersville. The headwaters of Buffalo Creek, which the first settlers followed to settle Rich Hill Township, ran though Wils's farm.

Salt Creek Church and Cemetery can be seen at the top of the painting of Wils Patton's farm. The church was torn down years ago when its congregation merged with the Rix Mills Church.

Paul Patton died in 1999. His grave is in Salt Creek Cemetery, close to the road. Before his death he and his wife's tombstone was inscribed with "We like this view."

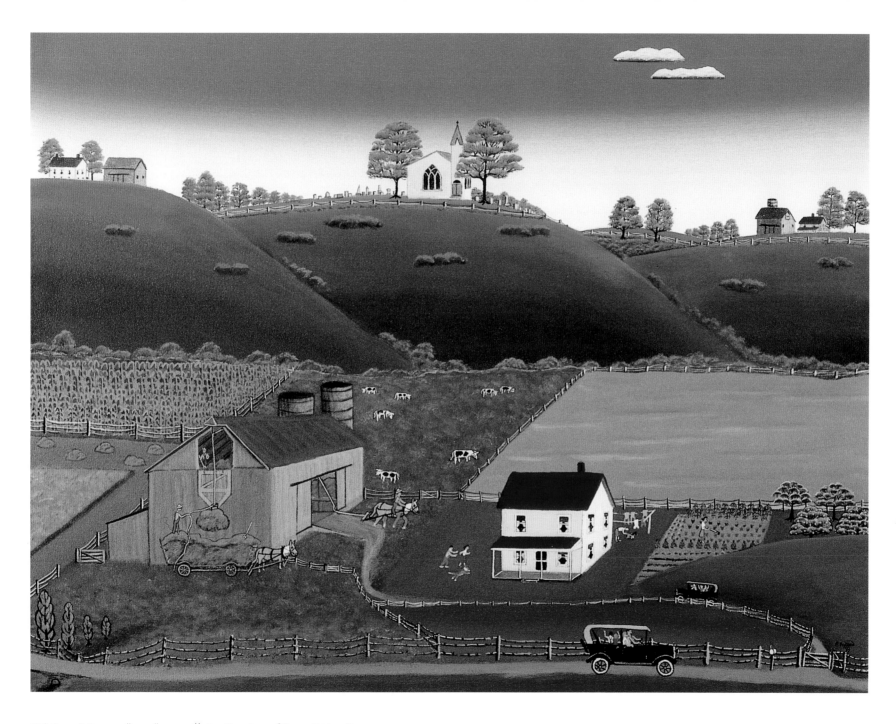

Wils Patton's Farm. 24" x 30", 1993, #364. Courtesy of Susan Patton-Fox.

Sunday Visitors, City Cousins

Summers were good times, too: Saturday evening softball, pitching horseshoes, swimming in the creeks. The 4-H clubs blossomed, and the church young people's meetings were well attended. The Muskingum County Fair in August capped the summer.

Most families in the countryside had city relatives or friends who liked to come visit them on Sundays in the summer. In Rix Mills the Sabbath was observed so strictly that there wasn't much we could do, but Sunday visiting was all right—as long as the children didn't play.

Women admired flower beds and gardens while men hunkered down on the front porch and talked politics, Republican politics (Muskingum County had two factions of Republicans). And young folks tried to get away with unapproved behavior, like jumping in the straw stack.

Sometimes a city cousin or two would visit for a week. They told great stories of their life in the city but were crazy to do "country" things. They chased the cats, rode the pony, fished the creeks, jumped in the hay, swam where the creek was deep enough under the bridges, ate green apples, and got sunburned and poison ivy. After they left with bags of vegetables, itchy skins, and belly aches, we talked of how great it would be to live in the city.

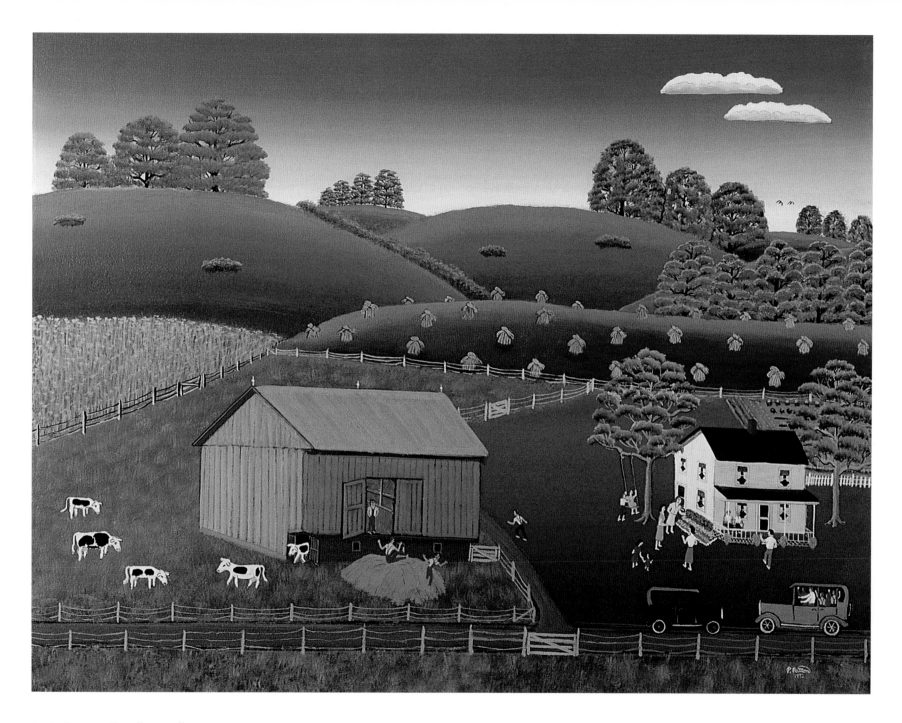

Sunday Visitors. 24" x 30", 1992, #355.

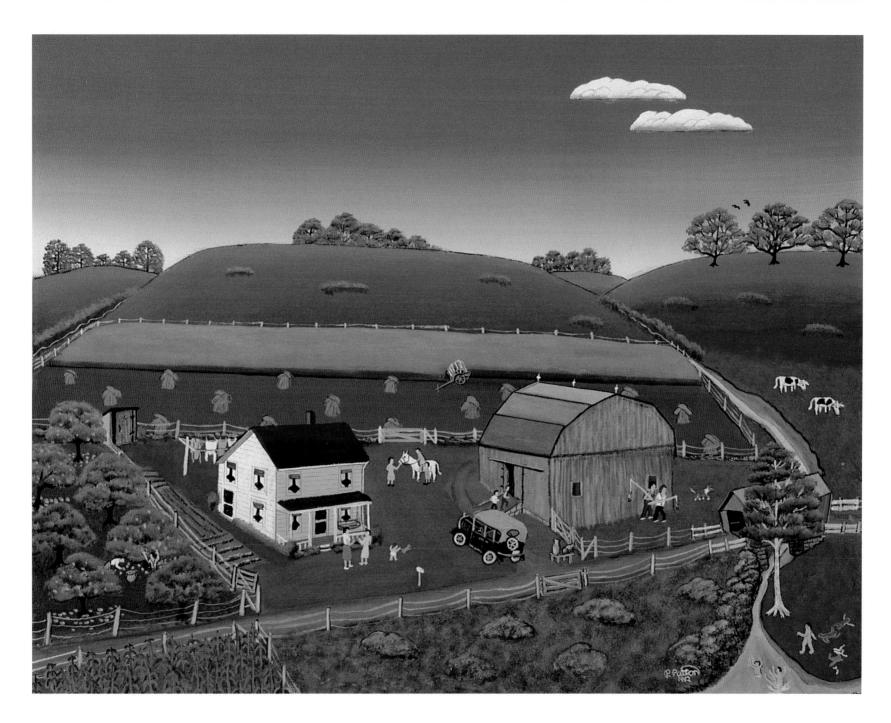

City Cousins. 16" x 20", 1992, #357. Courtesy of Eric and Amanda Marsh Simon.

The Haymow

Before boys were old enough to help in the fields with haying, we played in the haymow. Several times a summer I would walk barefoot to the Aitkens' farm two miles down the gravel Claysville Road from our house. Dick, Hap, Jim Aitken, and I and whoever else might be there would climb the ladder to the haymow and play tag on the beams.

Our shouts echoed in the cavernous barn as we dared and double-dared each other to climb higher or jump further. I stopped listening to the dares after I fell to the floor from the cross beam in the Aitkens' barn. John Aitken, the father, softened the blow by picking me up and sitting me on his lap—a new experience for me. I learned to be careful, very careful, on the beams.

There were five Aitkens: Bob, Hap, Dick, Jim, and Chloris. They gave us our most prized possession, our dog Rags. They told us she was a pure-bred Boston bull without the papers, and we never doubted it. She was the love and delight of our family for sixteen years.

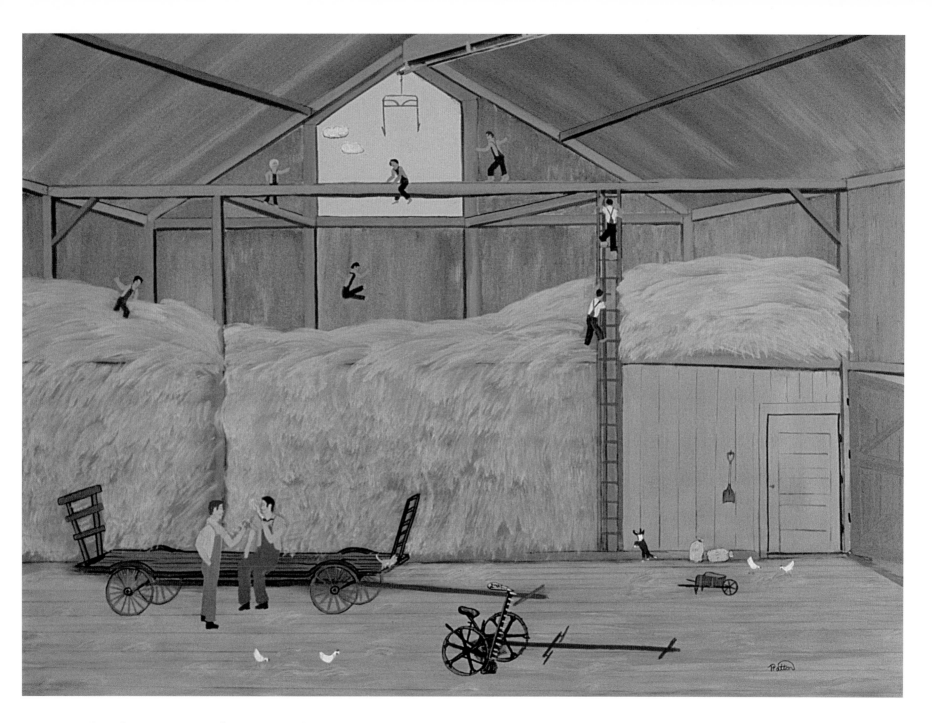

The Haymow. 18" x 24" on masonite, 1989, #159. Courtesy of Susan Patton-Fox.

Bible School

The church took Bible School very seriously. In the summertime morning classes we started to learn prayers, memorize Bible verses, and sing "Jesus Loves Me" long before we entered first grade. Boys generally dropped out by the time they were old enough to drive the team and hoe corn (about age eight).

Margaret Barnett, the New Concord High School Latin teacher, ran the Bible School. It was easy for children who lived in Rix Mills to be on time, but some farm children were always late, held up by chores and emergencies. They tried to sneak by Margaret's sharp eye, but they never made it.

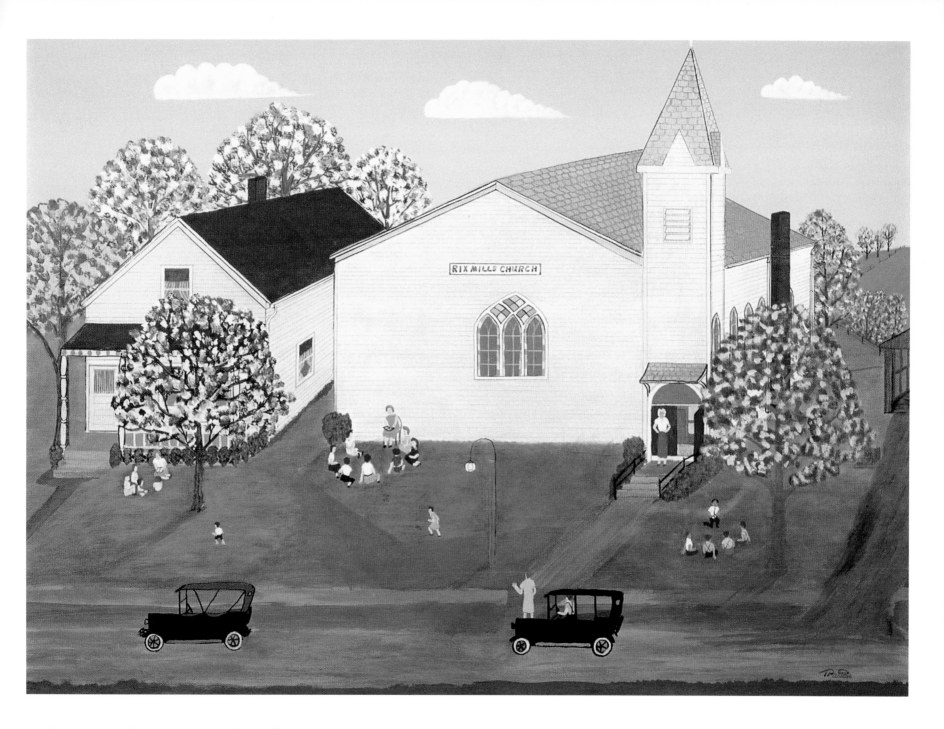

Late for Bible School. 18" x 24" on canvasboard, 1987, #58. Courtesy of Judy Kelly West.

Fishing at Rough and Ready

Before we were old enough to be of much help, my sister Dorothy and I, the youngest in the family, roamed the village and fields and woods around us. Early on we found the wild raspberry bushes and chestnut tree on Ben St. Clair's big hill across the road from our house. The creek in Emery Watson's pasture was just over our back fence, and we waded in the shallow pools, chased minnows, and watched the barn swallows bathe in clear water.

When we got older Dorothy and I sometimes spent a whole day fishing at Rough and Ready, about four miles down the creek toward Claysville. I would dig earthworms for bait and put them in a Bull Durham pocket can with some earth. Dorothy made peanut butter sandwiches for lunch. With our lunch, bait, fishing poles, and dog Rags we headed down the creek.

We followed the creek through fields and pastures, stopping for friends as we passed along the way—Verna Forsythe, Edna Sims, and one or more of the Aitkens, Chloris, Bob, Dick, or Hap. One creek after another emptied into the stream we were following and it grew wider. As we neared Rough and Ready, fish bigger than minnows were swimming in the deeper pools, and water snakes curled their way along the banks of the creek. Rags scouted the roots along the bank for snakes. When she found one, she dragged it out of the water and slapped it from side to side until it gave up the ghost.

We fished and snaked our way down the creek until we reached Rough and Ready school. This one-room grade school got its name early: It was supposed to have been called Mt. Auburn, but in August of its first year, when the school board asked the contractor if the building was finished, he is reported to have said, "It's rough but it's ready." From then on the creek, the school, and the road running by were all called Rough and Ready. The Rough and Ready road sign still stands along the two-lane county road.

The fish we caught were mudsuckers, ugly suckers, not much interested in our worms, and full of bones. We would string the "keepers" on a string about twelve inches long and drop them in the water as we went from pool to pool. I remember carrying them all the way home only once. My mother used them to fertilize the muskmelons.

Fishing was an all-day affair. We reached Rough and Ready about noon, ate our sandwiches on the bank, fished the pool, and then headed for home, wading in the cool water. We got home in time to wash off the fish scales and eat supper. We didn't fish all that often, and none of us ever developed a taste for fish.

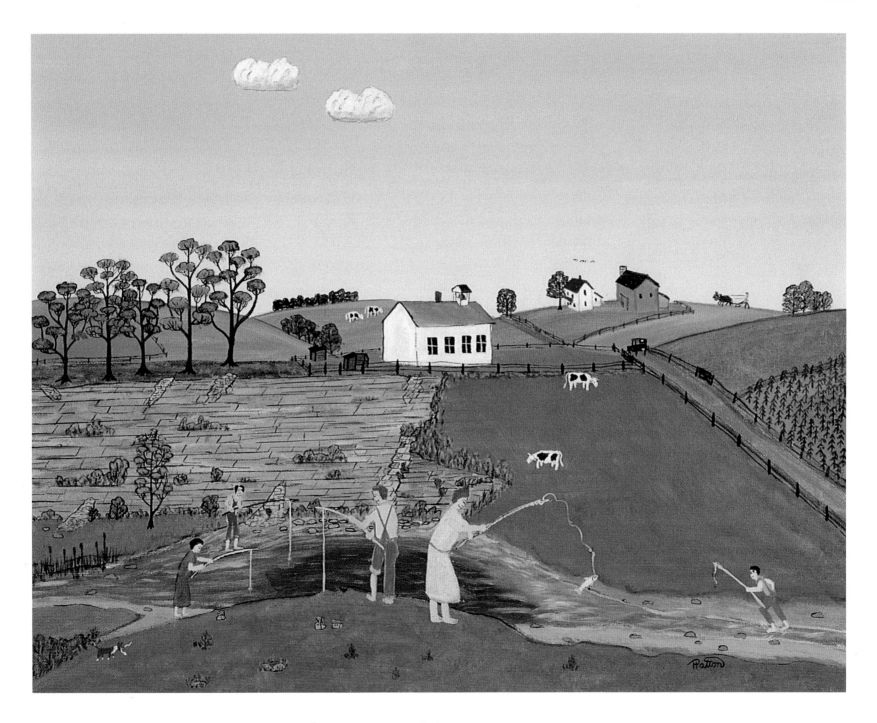

Fishing at Rough and Ready. 16" x 20" on canvasboard, 1989, #141. Courtesy of David Klausner, M.D.

Pitching Horseshoes

Whenever we had time away from our chores or were in town, we pitched horseshoes. The horseshoe pits were in the churchyard beside the driveway, and the set of four pitching horseshoes was always available at the general store. A boy could practice alone, two might compete, or four would play in teams of two.

Scoring went like this: a ringer was three points, a "leaner" was two points, and a "nearby" (no more than one horseshoe width from the peg) was one point. Whoever scored 21 points was the winner. My brother Ralph, a born competitor, was the horseshoe champion. I don't remember ever seeing girls pitch horseshoes.

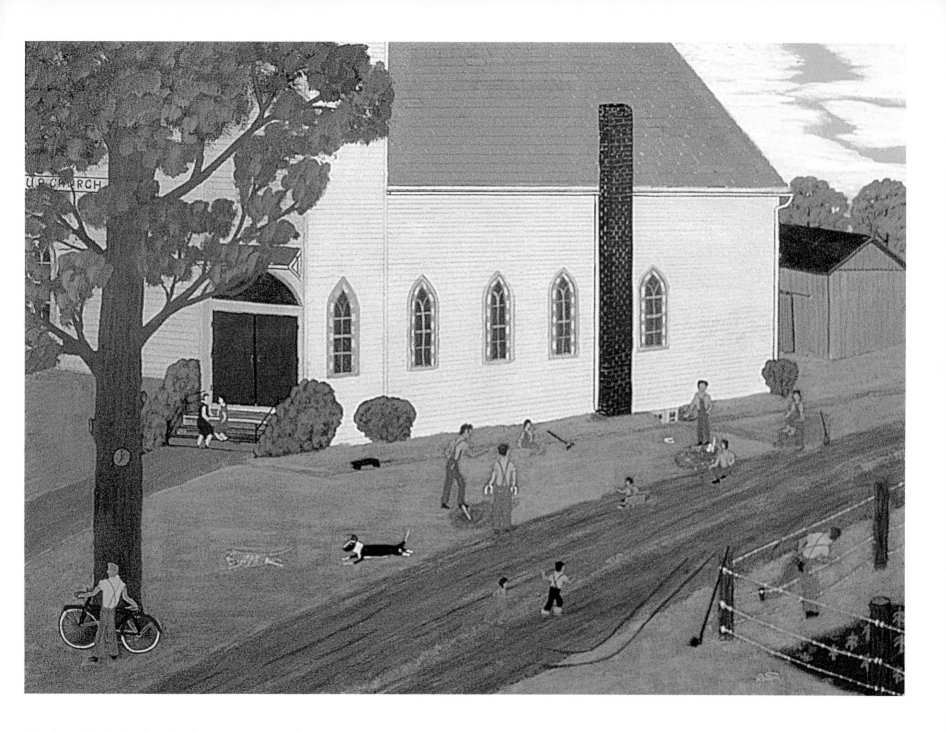

Horseshoes in the Churchyard. 18" x 24" on masonite, 1987, #67.

Night Fright

My sister Marion was eleven years older than I. She planned on being a teacher, and she taught me a lot of things. On summer evenings when I played in Rix Mills, she warned me to be sure to come home before dark. I had to walk down a country road from the main road in Rix Mills to get home, and the only street light in the village was a gas lamp in front of the church. Any detail Marion forgot to tell me my imagination could easily guess.

At dark ghosts and dead people came out of the pit under the coal scale in front of Emery Watson's house. Wild dogs came out of the bushes on Ben St. Clair's hill. Gypsies hid in the cellar under the carpenter shop and came out at night to steal little boys. Great black vultures were apt to swoop down from the sky.

I always lingered to play in Rix Mills until after dark. Each night I started out bravely in the pitch dark. But by the time the coal scale loomed ahead in the darkness and some horse or cow made a shuddering noise nearby, I lost my nerve and raced wildly down the gravel road until I reached home.

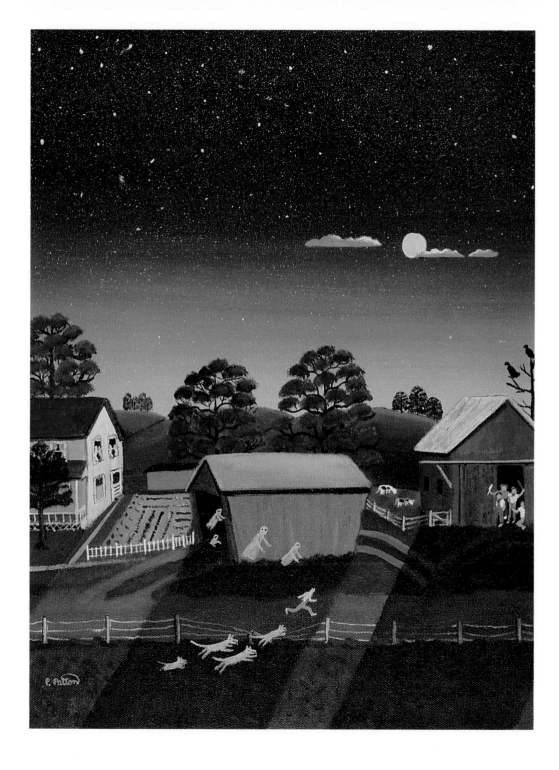

Night Fright. 18" x 14", 1993,
#405. Courtesy of Pat Hammel.

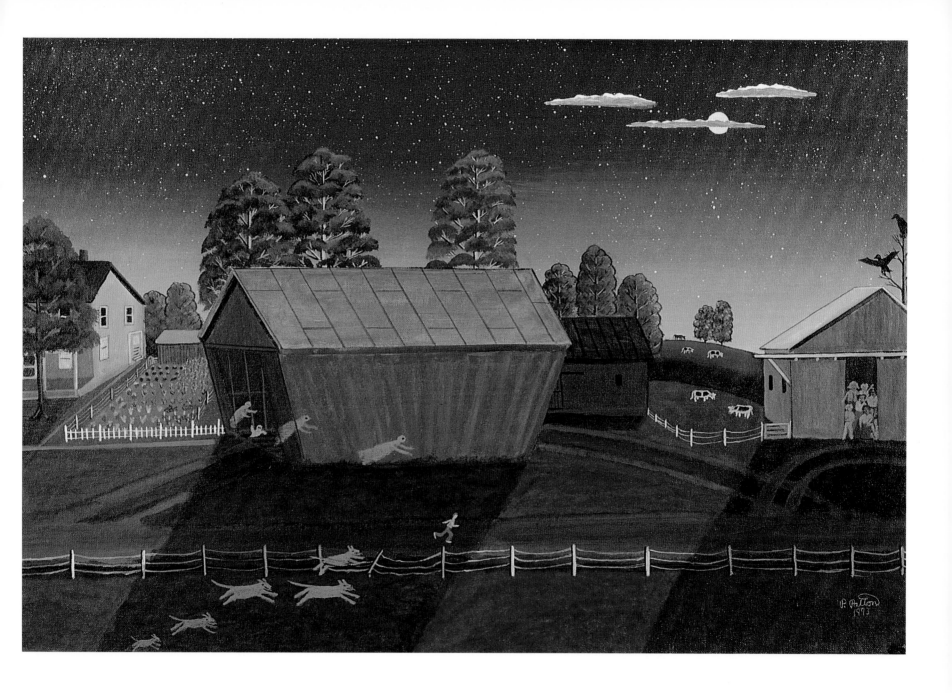

Night Fright. 20" x 30" on canvasboard, 1993, #367. Courtesy of Paul and Darice Nelson.

Swimming

After hoeing corn and shocking hay on a hot summer day, swimming in one of the creeks near Rix Mills felt good. One of our favorite swimming holes was just below the covered bridge at the Weekley farm, two miles down the lower road to Chandlersville.

Swimming parties were generally spur of the moment. When I got the corn hoed, the hay shocked, or the tomatoes weeded early and started out for the Weekleys, I would stop by Glasses to see if Joe was free, then by the McCormacs to see if Bill or Sam or John could go, then by Myron and Kenny Elliott's and Irvie Patton's—all on the way to the Weekleys.

Two creeks that wound their separate ways through my Uncle Perl Elliott's farm and Wils Patton's place came together at the Weekley farm to form a pool about three feet deep—deep enough for growing four-foot boys.

The farm house stood on a bank fairly high above the road, and a large sycamore tree beside the creek provided a little privacy for farm boys as we shed our bib overalls and jumped into the water. When we heard a car coming, someone would shout, "Car coming!" and we would duck in the water or jump behind the sycamore tree.

Rough and Ready was another swimming hole favored by the young people of Rix Mills. It was four miles east of Rix Mills, just off Route 76 (now Route 83) between New Concord and Claysville. The water there was deep, well over our heads. Four miles was too far to walk, though, for a spur-of-the-moment swimming party.

Sometimes, on a hot summer evening, Ray Glass would take a bunch of boys in his Model-A Ford to Rough and Ready. Any boy who happened to be in town that night joined the swimming party—often my brother Ralph and I; the Aitkens, in from their farm, Bob, Hap, Dick, and Jim; Myron and Kenny Elliott; and the Glass boys who were still at home, Herb, Joe, and Earl. We filled the car and the rumble seat, stood on the running boards, and lay on the front fenders, hanging on to the headlights and the radiator.

The girls must have gone swimming, too, but they didn't go with us.

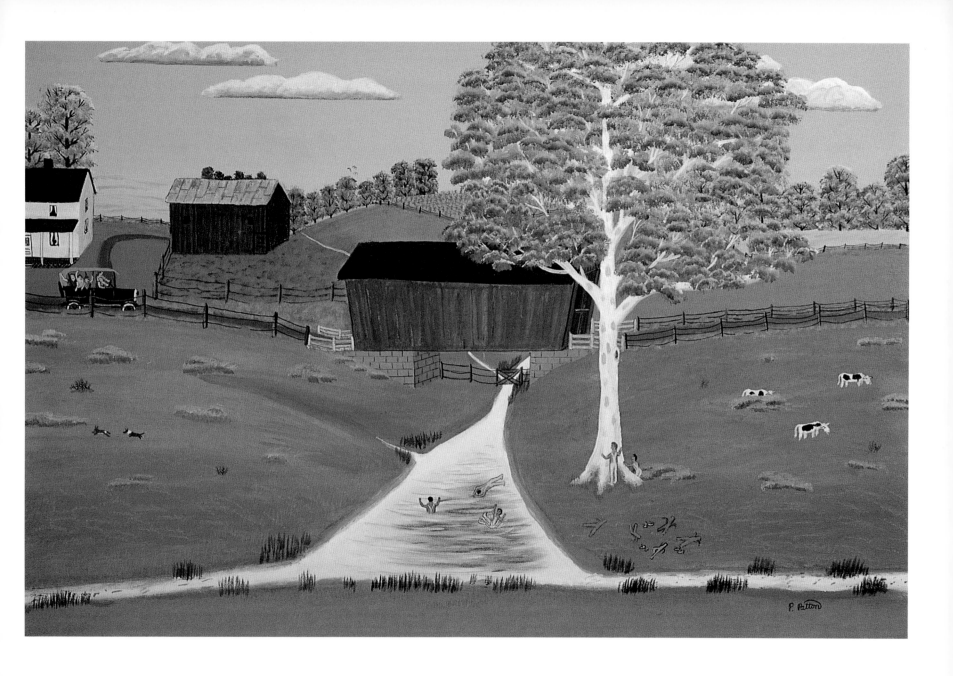

Swimming at Weekleys. 20" x 30", 1991, #290. Courtesy of Nurenberg, Plevin, Heller & McCarthy, Co. LPA.

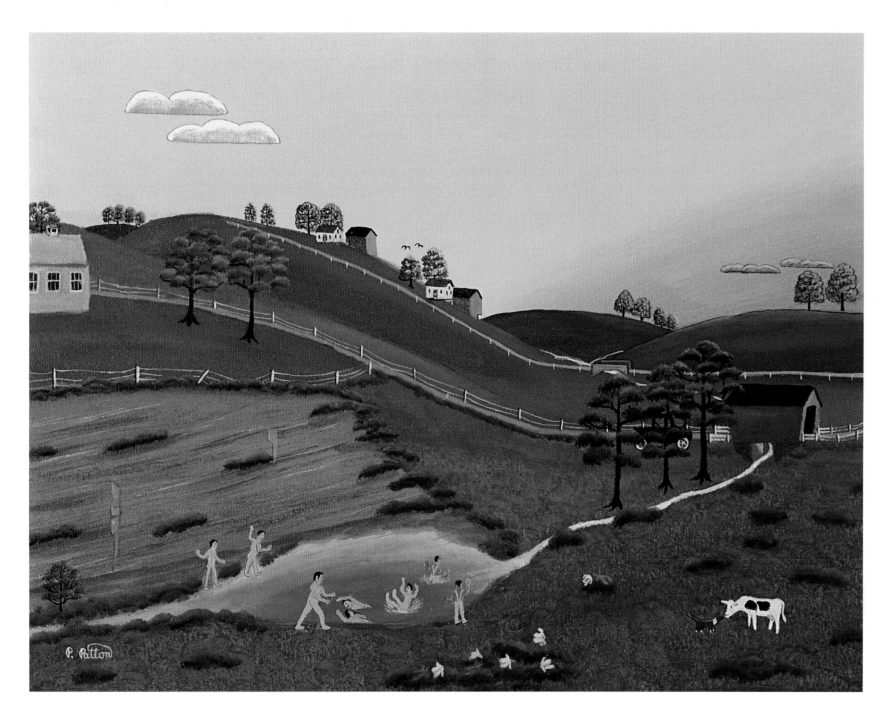

Swimming at Rough and Ready. 16" x 20", 1994, #438. Courtesy of Nicholas Domenick.

Wednesday Evening Prayer Meetings

Wednesday evening was prayer meeting night. This gave women a chance to worship together and a chance to visit awhile with friends. This was especially important for the older women in the village whose children were grown. My Aunt Ada, whose husband was storekeeper Johnny Campbell Watson, had no children. She went to prayer meeting every Wednesday night. Men were welcome, but they generally chose to spend Wednesday evening in the general store visiting with their neighbors not seen during the week.

Most folks living in Rix Mills were elderly. Many had retired from their nearby farms, deeded the land to the oldest son, and moved to town. On Wednesday evenings in the summer the son would drive into town and bring his wife to church and then deliver farm produce to his parents before heading to the store.

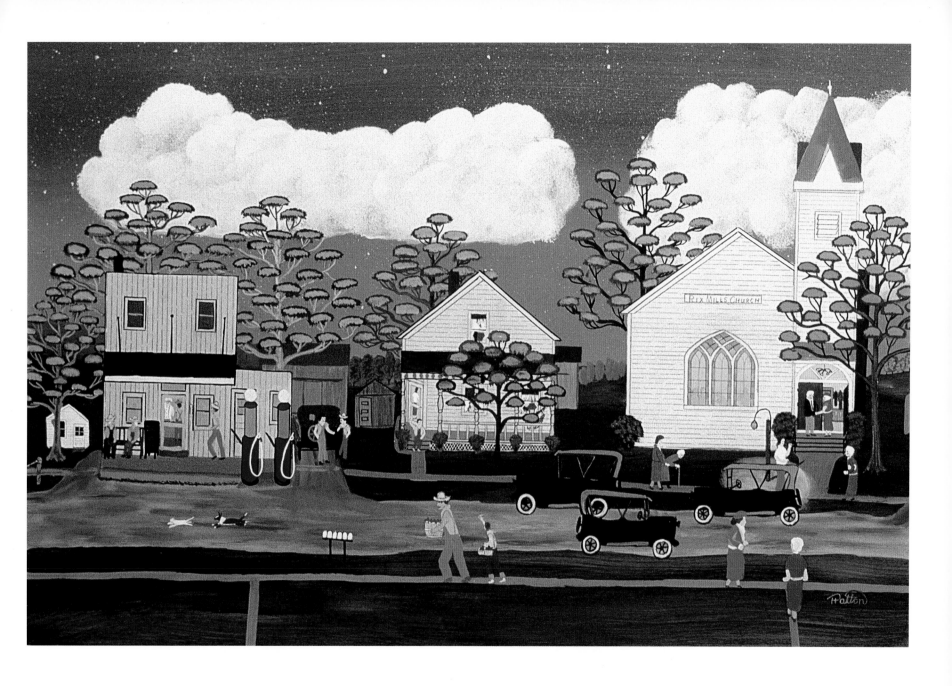

Prayer Meeting Night. 16" x 24" on masonite, 1988, #92. Courtesy of Wendy Patton (Garrity).

Saturday Night, Sparking

In the summer Rix Mills came to life on Saturday nights. After six work days, dawn to dusk, farm families looked forward to Saturday night and then a day of rest on Sunday. They started slowing down on Saturday afternoon: farm work stopped, and milking and other evening chores were finished early. Then young folks, fathers, and mothers headed for Rix Mills in their Model-T Fords.

On Saturday night women stopped at the general store and visited with friends and relatives. Men loafed on the store porch, smoked their pipes, and talked with their neighbors. Young folks played softball on the school playground until dark. Both boys and girls played, and some fathers joined in regularly.

When it was too dark for softball, we trooped up to the churchyard, where the only street lamp in the village provided a meager gaslit glow for games. Prisoners' Base was popular; this was a team tag game, with the preacher's cherry tree one base and the lamp post the other. The winning team had to tag all the players of the other team and put them in prison, or one member of the winning team was able to circle the other team's base. In trying to free teammates, prisoners stretched human chains toward their members.

Older boys and girls often lost interest in the game after a while and moved to the church steps. That was one of the few opportunities the young and restless in the country had to pair up. We called it sparking.

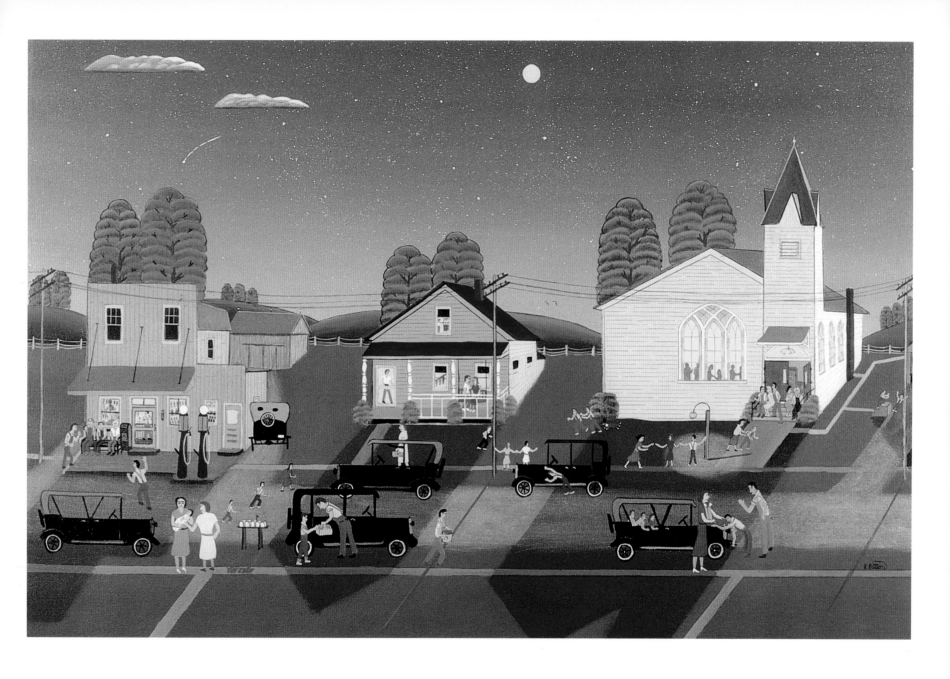

Summer Evening. 24" x 36", 1992, #317. Courtesy of the Ohio Historical Society, National Road/Zane Grey Museum, Norwich, Ohio.

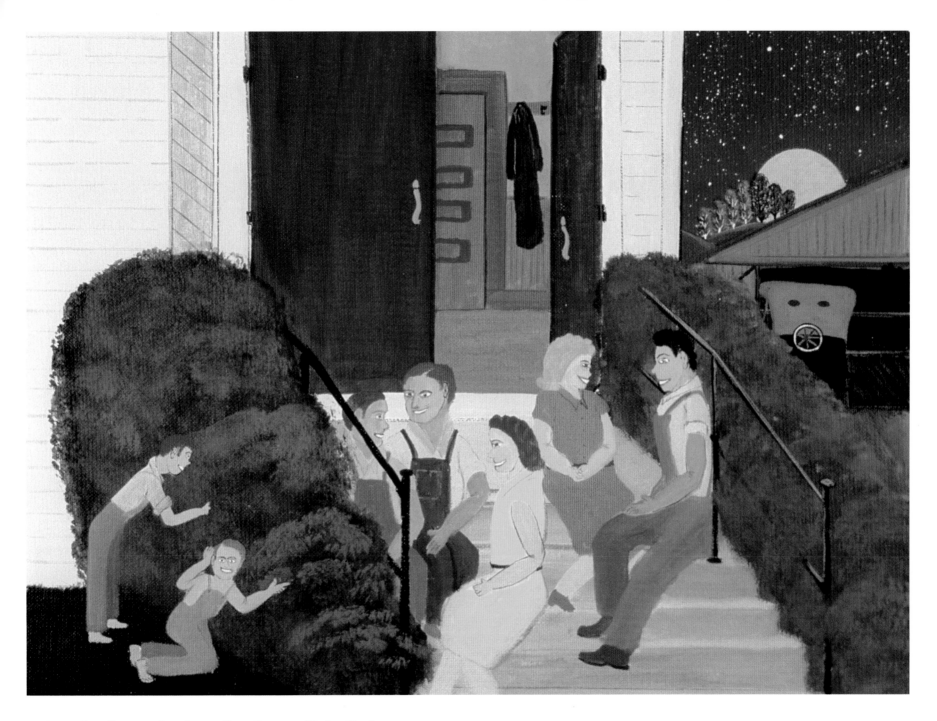

Sparking. 14" x 18" on canvasboard, 1990, #232. Courtesy of Barbara Vogel.

Saturday Night Ice Cream Socials

The summer I was eleven I got the idea of selling ice cream in the school yard on Saturday evenings, when the whole countryside came to town. We froze our own ice cream in winter when the creeks were choked with ice, but in summer, with no ice or refrigeration, we did without. I took my brother Ralph into the business because he was sixteen and could drive. We each put up five dollars and started Saturday night ice cream socials.

On Saturday afternoons Ralph borrowed the general store truck and drove to the Ohio Valley Dairy in New Concord to buy five gallons of vanilla ice cream, five gallons of chocolate ice cream (for the Fourth of July we bought five gallons of strawberry instead of chocolate), a couple boxes of cones, and some flat cardboard containers which, folded, we made into pints. We also borrowed two ice cream dippers. I borrowed two sawhorses and a section of the stage from the church, and with the help of Joe Glass set up a long table under the trees in front of the school.

Soon after eight o'clock we were in business, a brisk business. At five cents for one dip, ten cents for three dips, and five dips for helpers and best friends, we sold lots of ice cream. The ice cream socials were nice. They became a friendly kind of community gathering that summer with parents, children, and the elderly town folks all sitting on the school porch or teeter-totter or the grassy bank of the school yard by the road.

The only small discord came when Margaret Barnett asked for a dish of vanilla. We had no dishes, and she wasn't very happy about going home, a few houses down the road, to get her own dish and spoon, but she did. The next week we had dishes and spoons.

We held our last ice cream social the Saturday just before Labor Day. Ralph had a date with Verna Brewer that night, so after we closed up shop he took some money from the cigar box and left. The next day he said, "I took my five dollars and a little change. The rest is yours." I counted up and found I had $5.47. It had been a great summer, but there were no more summer ice cream socials.

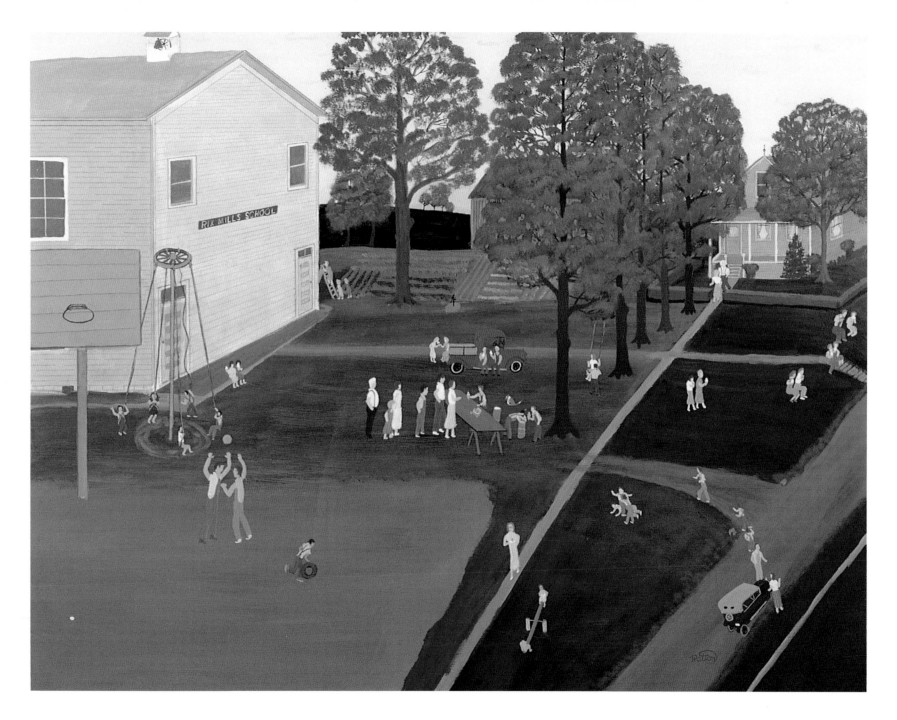

Saturday Night Ice Cream Social. 22" x 28" on masonite, 1988, #109. Courtesy of John W. Garrity.

Fourth of July

Rix Mills was too small to have a parade for the Fourth of July. Besides, the only living World War I veterans, Johnny Campbell Watson and Walter Kirk, had outgrown their uniforms. But we celebrated anyhow.

We generally began our Fourth of July celebration in early June. It was started by small boys buying five cents worth of carbide at the general store which they used to blow tin cans to smithereens on the sidewalk in front of the church. A thick vein of coal underlay the region, and mines had tunneled the hills for years. Miners bought carbide for the lamps they attached to their caps for light inside the mine. Mixed with water, the carbide formed a gas that could burn. The pungent smelling carbide came in small chunks. We would spit on a couple of these chunks, put a tin can on top of them, light a straw to act as a fuse, and run like anything. BLAM!

The big celebration came on the night of July 4 when Johnny Campbell Watson went up on the hill and set off real fireworks: Roman candles, whole packs of one-incher fireworks, some two-inchers, and spectacular whirligigs. Johnny Campbell set off all the fireworks that had not been sold at the Ledman-Watson general store, plus some other specials held in reserve. When we were "old enough" we got to go up the hill with him and set off a few ourselves.

Farm families came from miles around to watch the fireworks.

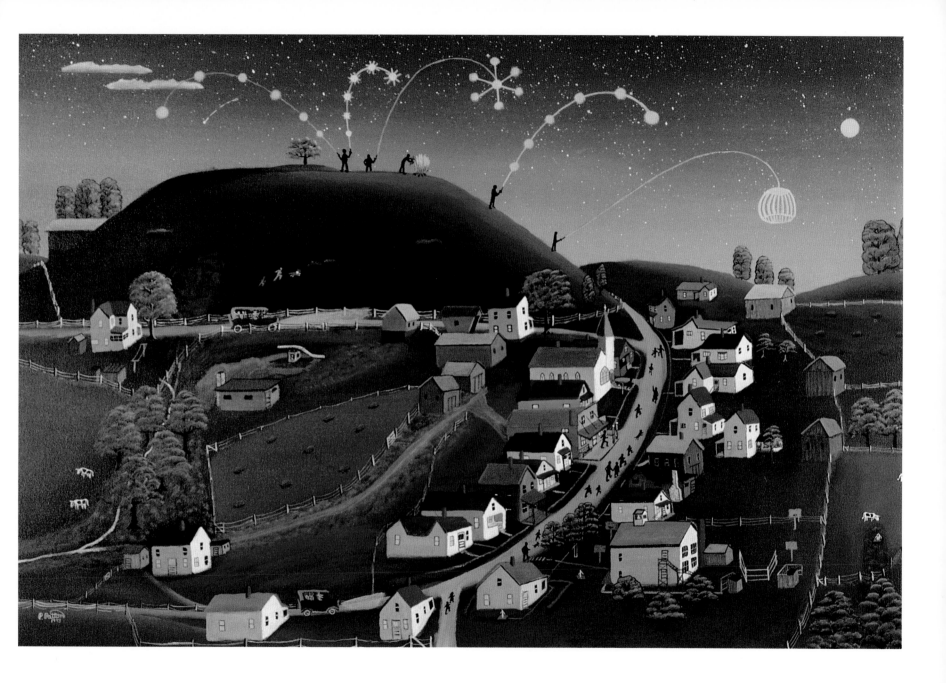

Fourth of July. 24" x 36", 1993, #366. Courtesy of Irving Rothchild, M.D.

Three Deep

One of our regular games at summer parties was called Three Deep, a tag game. Players would pair, one standing in front of the other, and all formed in a circle. One player was It and another, the prey, was to be tagged. They would chase round and through the circle. The prey could stop in front of any pair, and the player behind was then the prey. If It tagged the prey then the roles were reversed, and the prey became It and chased the other. This was an active game with lots of changes.

Three Deep also provided a chance for a little mild romancing. First, the choice of partner to stand with allowed for a show of interest. Also, standing with your fellow or girlfriend while group attention was on the chase allowed leeway for some gentle nudging and touching unnoticed by others. This romancing never got out of hand. Still, some of these young people married and are grandparents today.

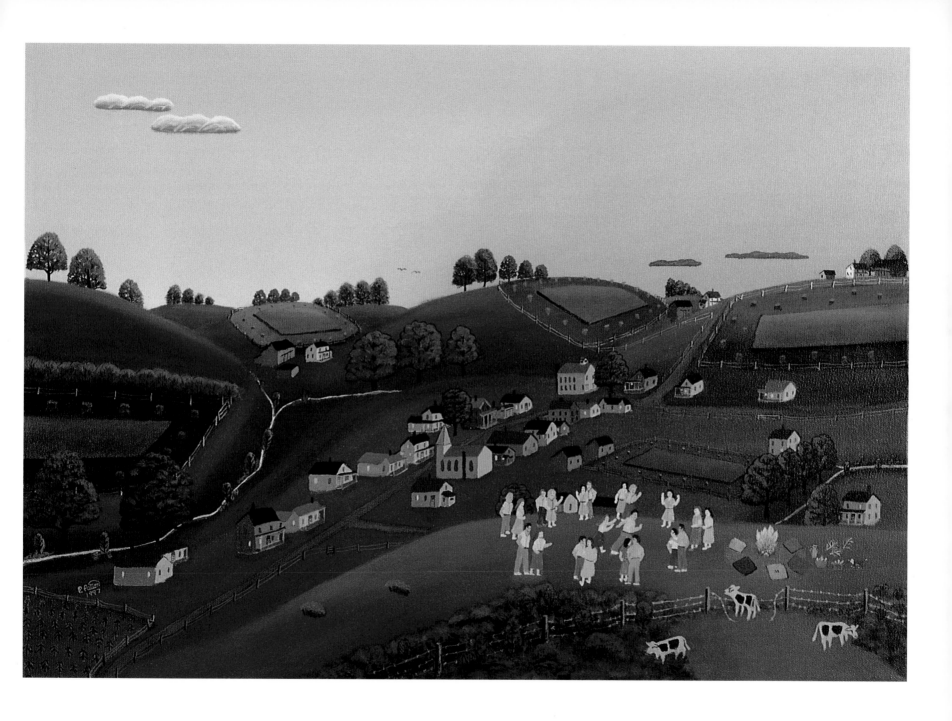

Three Deep. 18" x 24", 1997, #523. Courtesy of June and Ron Oshima.

A 1920s Belling

I remember the day my oldest sister Marion was married. That night half the countryside gathered at our house for a belling. Aunts and uncles, cousins, neighbors, and friends serenaded the newlyweds by making as much noise as they could with pots and pans and kitchen utensils, horns, and horse fiddles. When the noise finally reached a satisfying crescendo, Marion and Merlin came out on the porch to the applause and congratulations of the crowd. Marion passed out candy and Merlin gave the men cigars. I smoked my first and last cigar that night.

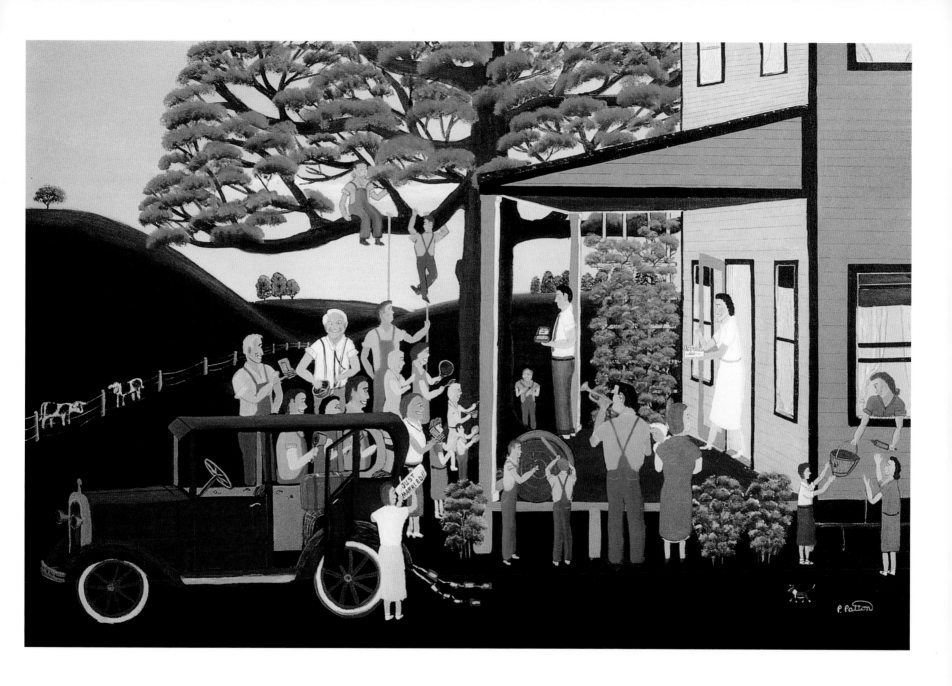

Belling Marion and Merlin. 24" x 30" on canvasboard, 1991, #285. Courtesy of Nurenberg, Plevin, Heller & McCarthy, Co. LPA.

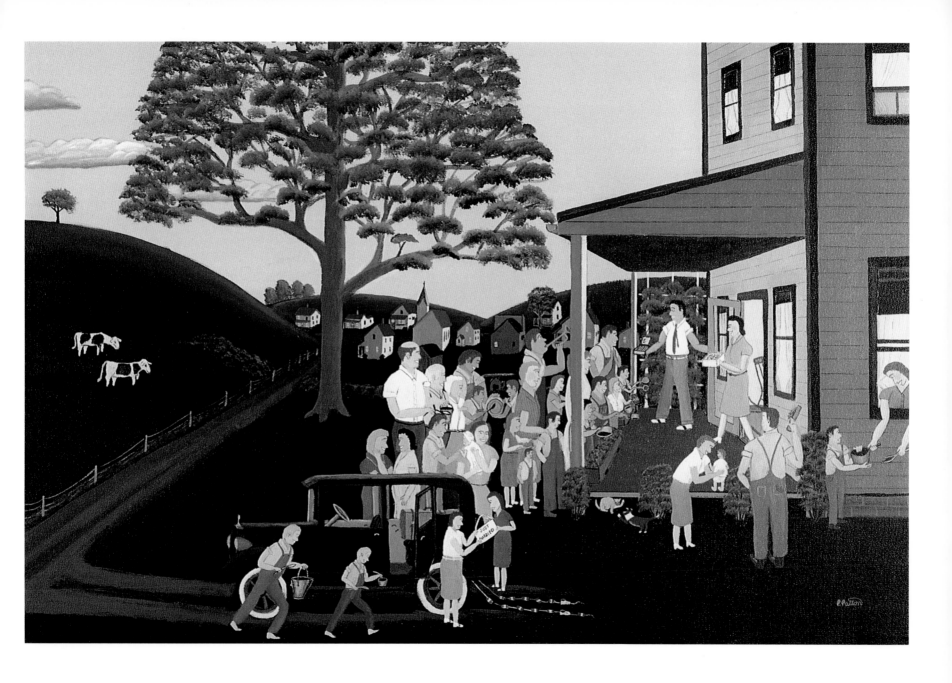

A 1920s Belling. 24" x 36", 1991, #300. Courtesy of Wendy Patton (Garrity).

4-H Club

4-H clubs blossomed in the spring and bore fruit at the Muskingum County Fair in August. 4-H was the one social group to which all young people in the countryside around Rix Mills belonged. Girls had their 4-H Snappy Stitchers Club. I imagine they sewed and maybe cooked, but we had nothing to do with them. Farm boys raised a calf or a pig and learned about animal husbandry.

Since I didn't have a calf or a pig, I was sometimes hard pressed for a project. At different times I collected butterflies, identified trees, and tied rope knots—anything to be a member of 4-H. Village boys like me joined for the games and wiener roast at the once-a-month meetings where we talked about our projects. Each year we displayed our work for judging at the county fair.

One year I entered a breadboard as my project. Some years before Ray Glass had taken woodworking as a project, and his father, our preacher, who also happened to be a good carpenter, helped him make a breadboard. It won a blue ribbon at the fair and became the family cutting board. The next summer my brother Ralph, with Reverend Glass's help, planed the knife marks away and entered the breadboard as a 4-H project and won a blue ribbon again. The breadboard then went back into use.

It got planed twice more, first for Earl Glass and then for me. When Earl entered the breadboard the yearly planing was showing, and he got a red ribbon. By the time I entered the breadboard, it was so thin I got only a complimentary white ribbon, given to anyone who entered anything.

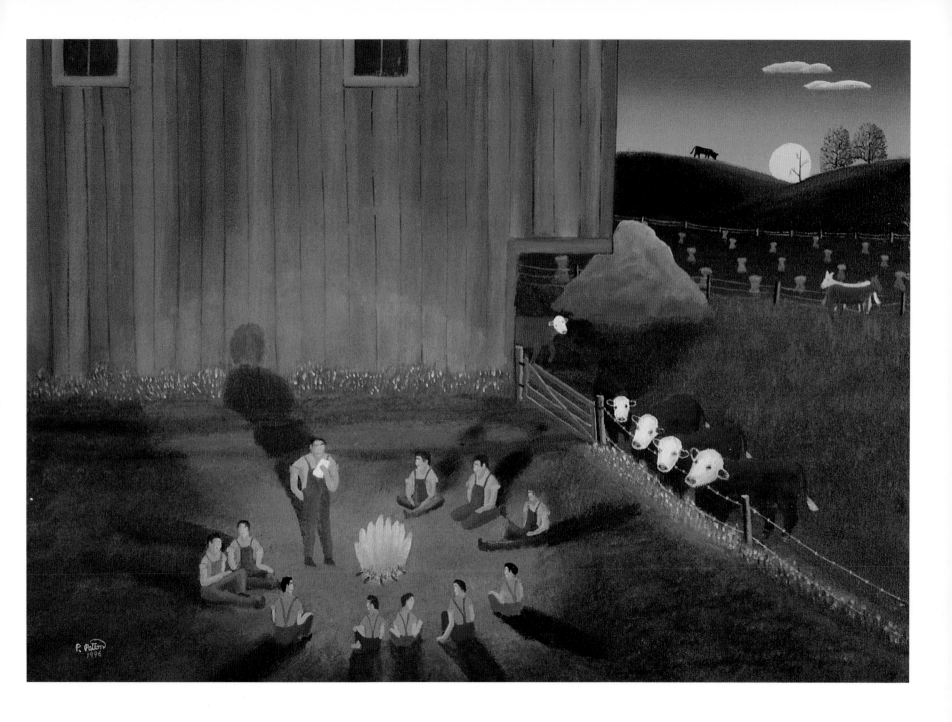

Fall 4-H Club Meeting. 18" x 24", 1996, #513. Courtesy of Irving Rothchild, M.D.

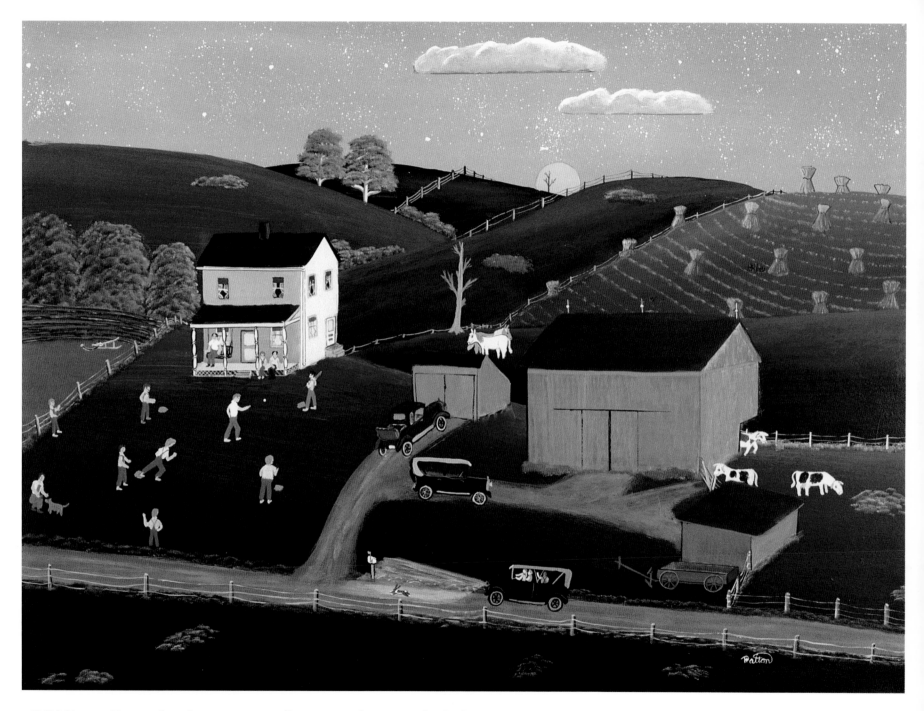

4-H Club Meeting at Herrons. 18" x 24" on masonite, 1989, #92. Courtesy of Margaret and Richard Wenstrup.

The Muskingum County Fair

The Muskingum County Fair in Zanesville in August was the high point of the summer for country folks, and it marked the end of the summer for us. Farmers around Rix Mills won prizes at the county fair for their pure-bred Jersey cattle and went on to win at the Ohio State Fair. Their sons and daughters exhibited calves and pigs and needlework in 4-H competitions. Mothers entered their preserves and pastries and quilts in Grange contests. We worked on our 4-H projects and saved our money all summer long for fair time.

At the fair I saw things I had never seen: sword swallowers, fire-eaters, the human skeleton, the fat lady, wing walkers, a ferris wheel, horse races. You could win prizes for knocking over wooden milk bottles or exploding balloons. When I was in fifth grade a friend, Delbert Van Reeth, invited me to stay overnight at his aunt's house close to the fairgrounds, and I got to go to the fair on two days. I also had my first bath in a bathtub, and I learned how to clean up that terrible black ring in the tub. One year I slept on straw in the cattle barn with my Elliott cousins, Myron and Kenny, and their champion steers, but not very well.

One or two of my uncles was always an officer on the fair board, and they always reserved a picnic table on the grassy knoll above the midway for Thursday lunch for Rix Mills. And what lunches! Pressed chicken and pork tenderloin sandwiches, potato salads, pickles, spiced pears, my mother's raisin pie, devil's food cakes, and more.

The county fair was our window on the world beyond Rich Hill Township.

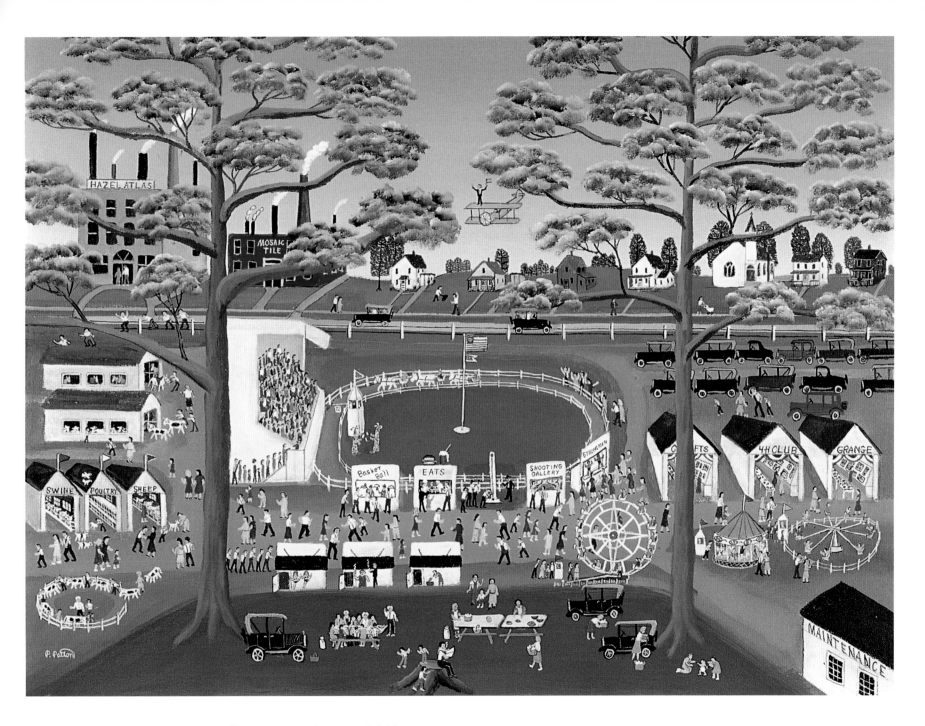

The Muskingum County Fair. 22" x 28", 1994, #450. Courtesy of Irving Rothchild, M.D.

Fall and Winter in the Village

School

The coming of fall brought an end to our summer's
work and our summer's freedom as well. After long
days of field work and farm chores, the opening of
school was a relief . . . for awhile: no more mowing,
raking, pitching and loading hay, hoeing corn, shocking
wheat, or building fence until next summer.

Almost all of us walked to school. I remember walk-
ing to school barefoot my first day with my sister Dor-
othy. My sister Marion's friend Dorothy Gregory rode
her horse, Boxy, to school and stopped for my sister
along the way. During the school day Dorothy Gregory
hitched her horse at Mayn Forsythe's. Donald
Crawford, the only boy I remember who didn't wear
bib overalls to school, rode a horse and kept it in the
church stable. Since Mr. Monroe's farm was beyond
Aitkens' farm, he stopped for them and brought them
to school in his car.

In September Mr. Monroe walked the entire grade
school up to the Ledman-Watson general store to be
weighed. We filed by the potbelly stove, past the candy
showcase and the dry goods counter, by Jim Ledman at
the cash drawer, and then by the coffee grinder to the
big platform scale in the back room of the store. There
Mr. Monroe weighed each of us and made a record of it
for that school year.

The early weeks of school were review, relearning
what we had forgotten in the four-month summer vaca-
tion, and we didn't have to worry about grade cards until

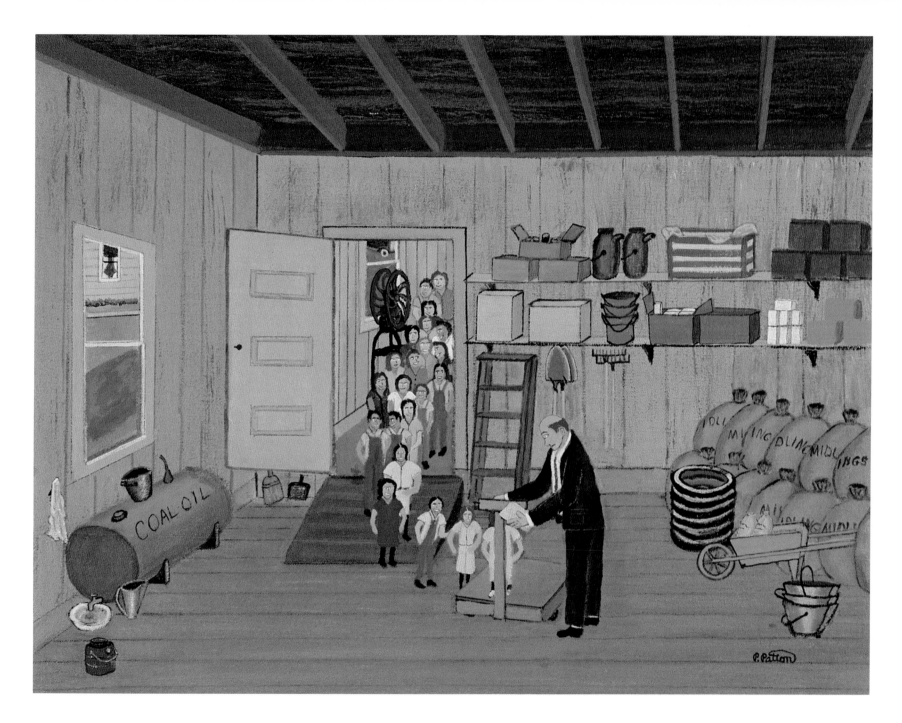

Weighing the School. 16" x 20", 1994, #429. Courtesy of Susan Patton-Fox.

Thanksgiving. Mr. Monroe had eight grades to teach, so reciting was constant, grade by grade, subject by subject, all day long. Upper grades had spelldowns each week. He was strict.

With his huge calloused hand, Mr. Monroe ended boys' rowdiness or whispering by turning heads back to the front of the classroom or firmly grasping a shoulder. When my sister Carol and her red-haired friend Lucy Wilson whispered and giggled, he lifted them up on a bookcase or the shelf in the cloakroom and talked to them eye to eye. In her seventies Carol still remembered what he had said. More than once my brother Ralph raced home from school to be the first one to tell my mother why he was punished before Carol could get home with her report.

We took turns carrying drinking water in a bucket from the Ledmans' well next door to fill the water jug in the cloakroom. Each of us brought a drinking cup from home and hung it on a hook on the cloakroom wall. A coalhouse and two outhouses stood in the back of the school. The privies, one for boys and one for girls, were unheated, unpainted, and uncomfortable. But they were acceptable, because none of us had plumbing or running water at home, except for the parsonage, where Reverend Glass and his sons had arranged an indoor bathroom for Mrs. Glass, whose health was very fragile.

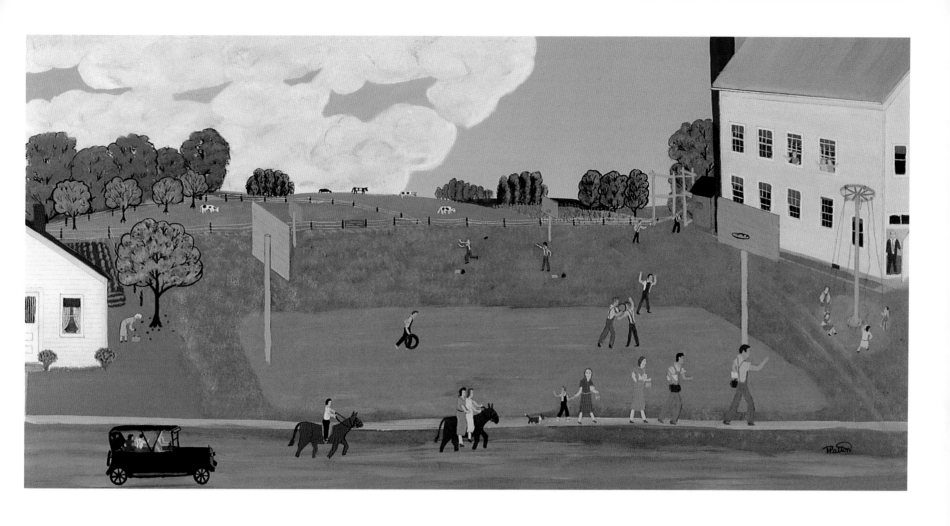

Going to School. 15" x 30" on masonite, 1988, #128.

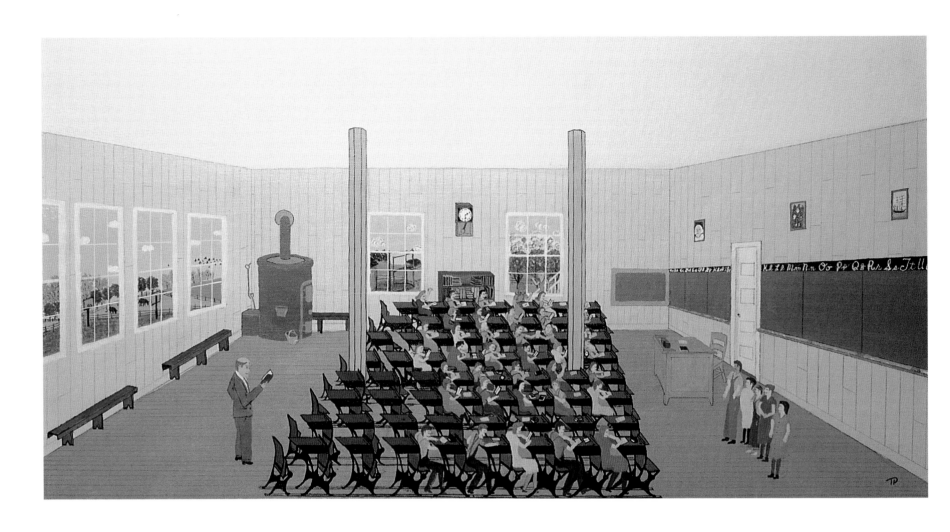

124 *Seventh Grade Spelldown.* 15″ x 30″ on canvasboard, 1986, #15. Courtesy of Michael Salkovitch, D.D.S.

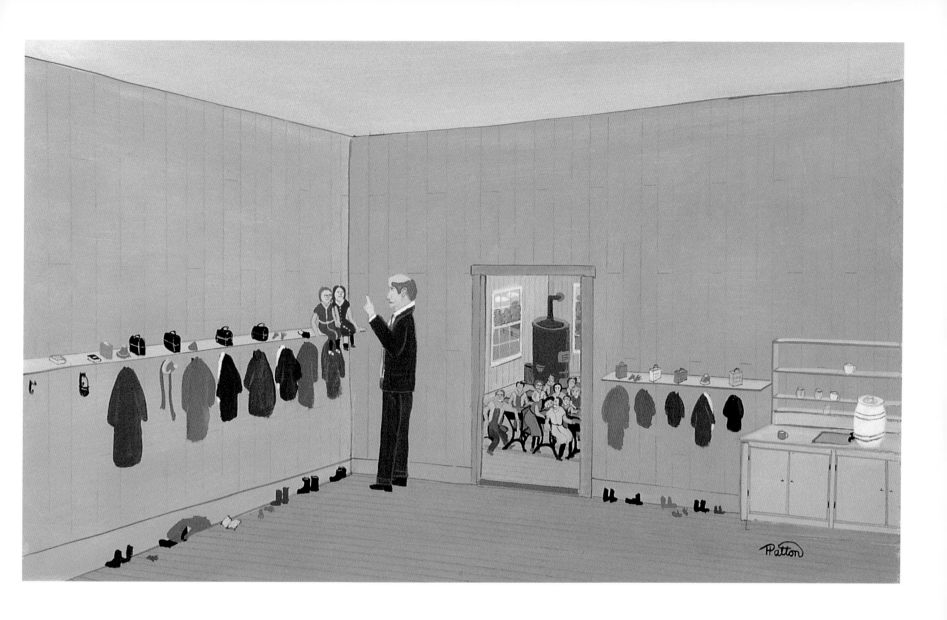

The Scolding. 12" x 20" on masonite, 1989, #137. Courtesy of Kay Carroll Dickinson.

The School Recess

The best thing about school for country boys was recess. We had fifteen minutes of recess in the morning and afternoon and an hour for lunch. We all carried our lunch. The playground was large, with a big playing field for softball and football, two basketball courts, and plenty of room for playing other games.

In the fall football was the game of choice for the boys. Sometimes Mr. Monroe would pull overalls over the suit he always wore and play football with us. I remember grabbing his suspenders and being dragged in giant steps across the field as he ran for a touchdown. If four or five of us tackled his legs before he reached top speed we could stop him, but once he got going he was sure of six points.

Anthony Over was an ongoing game, day after day. One team threw the ball over the roof of the coalhouse behind the school, shouting "Anthony O-O-Over," and then raced wildly around the coalhouse to catch as many on the other team as possible before they caught the ball. We played Prisoners Base, Red Rover, and Bull's Eye marbles. I never saw anyone roll a hoop, but there were plenty of old tires to roll.

Every boy carried a pocket knife for whittling spit

ball guns from elderberry stalks or for playing mumblety-peg. Mumblety-peg was played by opening both blades, one full and one half, and then making a number of throws of the knife, each ending with the knife blade stuck in the sod. Beginning throws were easy—front of hand, back of hand—but it quickly grew more complicated with throws from the elbow or the top of the head.

When the ball fields were too muddy we sometimes played a noontime game of hide-and-seek we called Run Sheep Run. We had an hour at noon, so we could leave the school ground and hide in barns and chicken coops, anywhere we liked. Irvie Patton took a team down the creek to the woods in back of his house one day, and we never did find them. They got back half an hour late and said they hadn't heard the bell.

One day during recess a biplane flew over our playground. It circled around and then flew closer to the ground, so close that we could see the pilot in his helmet and goggles. In my mind's eye I can still see that pilot. Lindbergh's flight over the Atlantic Ocean in 1927 had excited all of us.

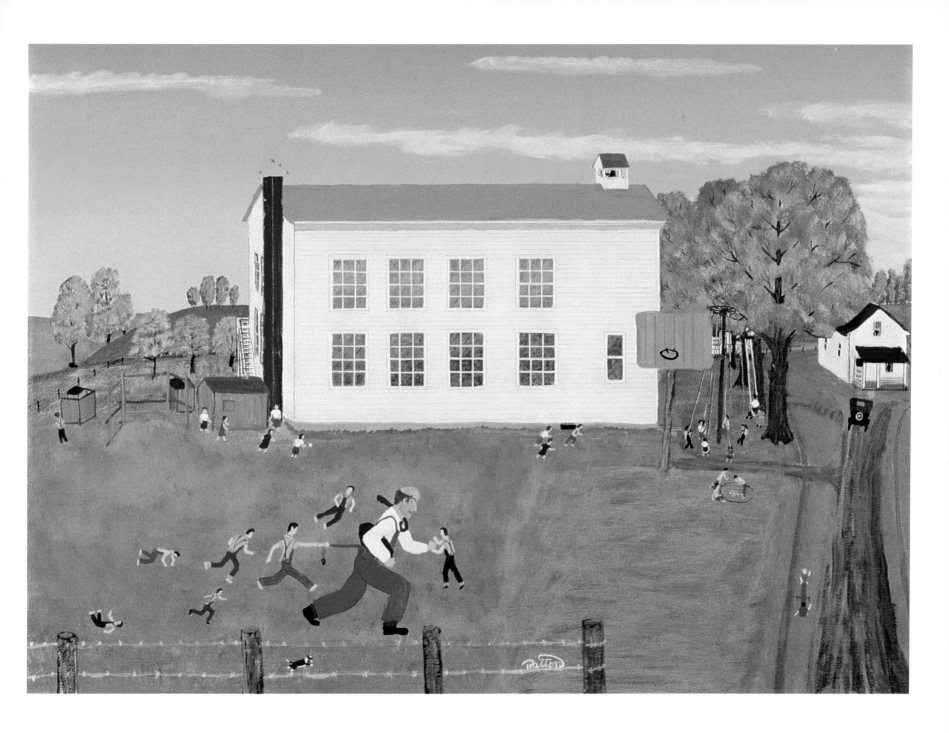

Sometimes Mr. Monroe Played Too. 18" x 24", 1987, #76. Courtesy of Dorothy H. Vernia.

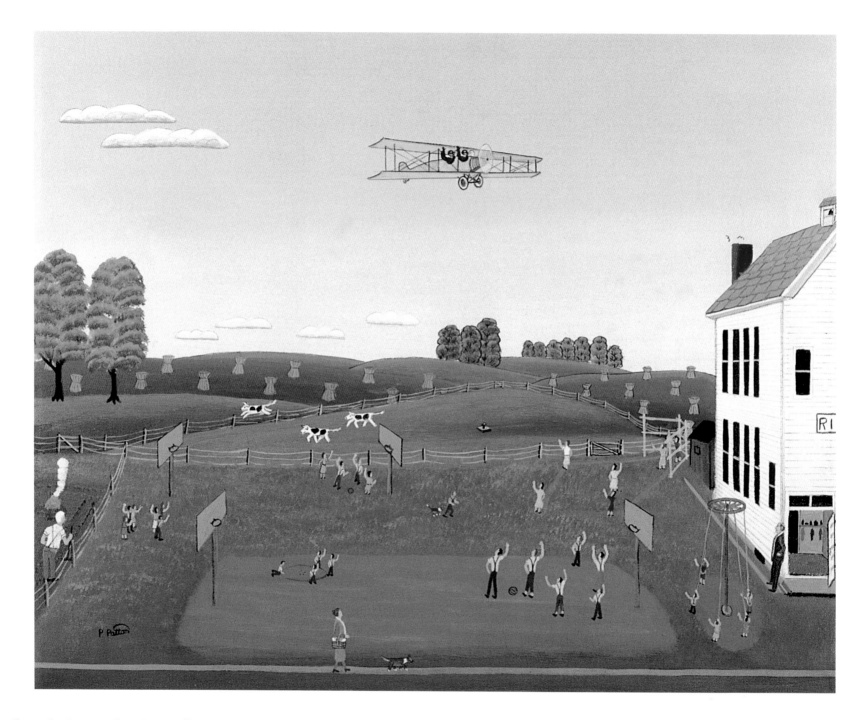

128 *After Lindbergh, 1927.* 18" x 24", 1992, #308. Courtesy of Margaret and Richard Wenstrup.

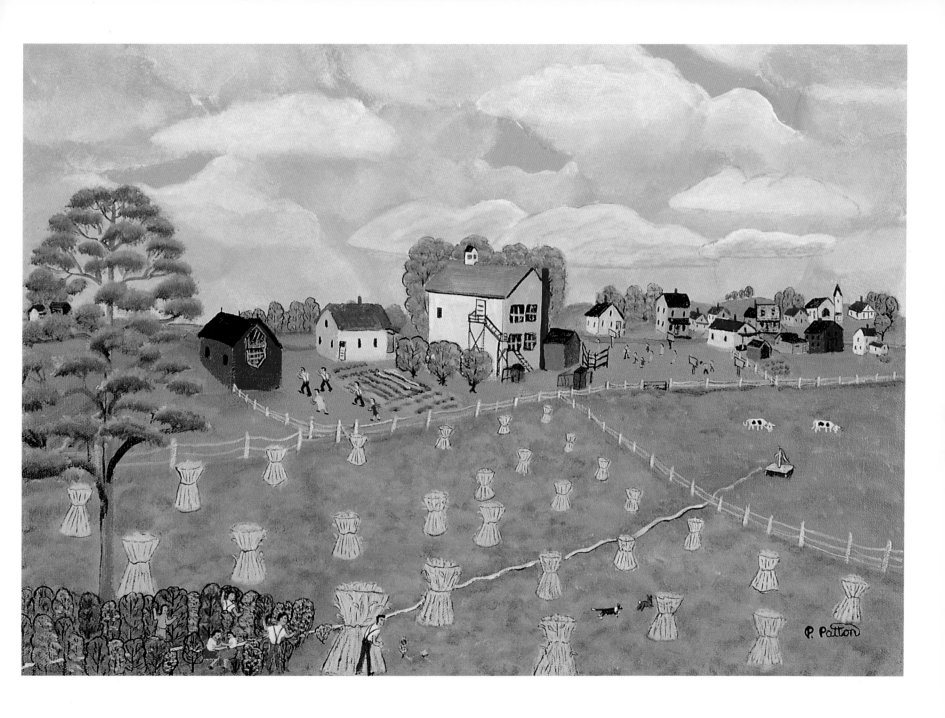

Run Sheep Run. 13" x 18", 1994, #433. Courtesy of Curt Edwards.

The Teacher Will Be a Little Late Today

My sister Marion saved her money from her jobs as school janitor, telephone switchboard operator evenings and weekends, and boarding out in summer and graduated valedictorian of her two-year normal school class at Muskingum College. Marion's first teaching job was at the one-room Dublin grade school, a little white frame building in the back of Leland Watson's farm, about three miles from our house. Her eight or ten pupils came from three farm families of Whites, Elliotts, and Watsons.

Since we had no car or horse, Marion walked to school each day. When the weather got really bad, she "boarded round" among the farm families. Most of the time she walked to and from school along the Claysville Road, but she could save quite a distance by cutting across the pasture to school.

The problem with the shortcut was that Leland pastured his dairy cows—great red beasts with white faces—in that pasture, and Marion was deathly afraid of cows. And while they were not mean, the cows were curious and would tend to hurry over to anyone in the pasture.

Halfway across the field a clump of willows offered protection because the trees were too close together for the cows to enter. So when Marion misjudged and the cows got too close, she would run into the willows until the cows drifted away.

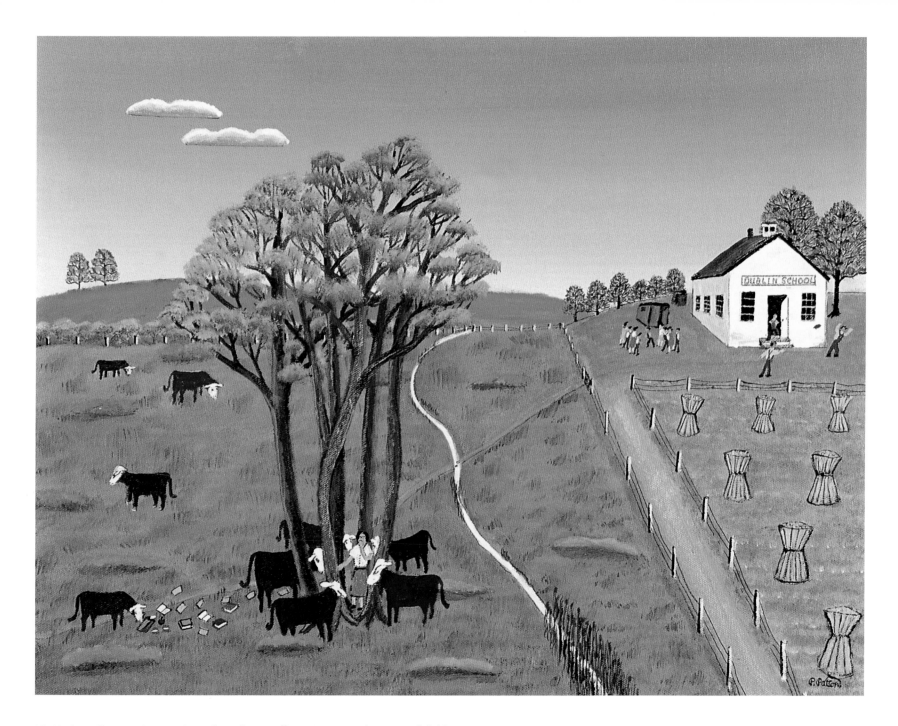

The Teacher Will Be a Little Late Today. 16" x 20", 1994, #447. Courtesy of Irving Rothchild, M.D.

Wiener Roast at Mooreheads

During the long golden Ohio falls, we enjoyed wiener roasts at Mooreheads' woods. The Moorehead farm was a half-mile east of Rix Mills on the Claysville Road. The social chairman of the 4-H Club or the Young People's Society would ask Robert Moorehead, and later his son Mark, for permission to use the woods for a wiener roast, and it was always given.

The girls brought the food, and the boys gathered wood, built the fire, collected switches for roasting, and cleaned up afterward. We came, roasted wieners, played, sang, sparked a little, and went home.

The Mooreheads' granddaughter Agnes was Rix Mills's nearest claim to fame and riches. The famous actress inherited the farm and was one of the few owners who could afford to refuse to sell her property to the coal company. The Moorehead farmhouse still stands. Before she died Agnes Moorehead built a house back in the woods precisely at the spot where we had our wiener roasts.

Dorothy's Wiener Roast. 18" x 14", 1991, #259. Courtesy of Paul Aguiar.

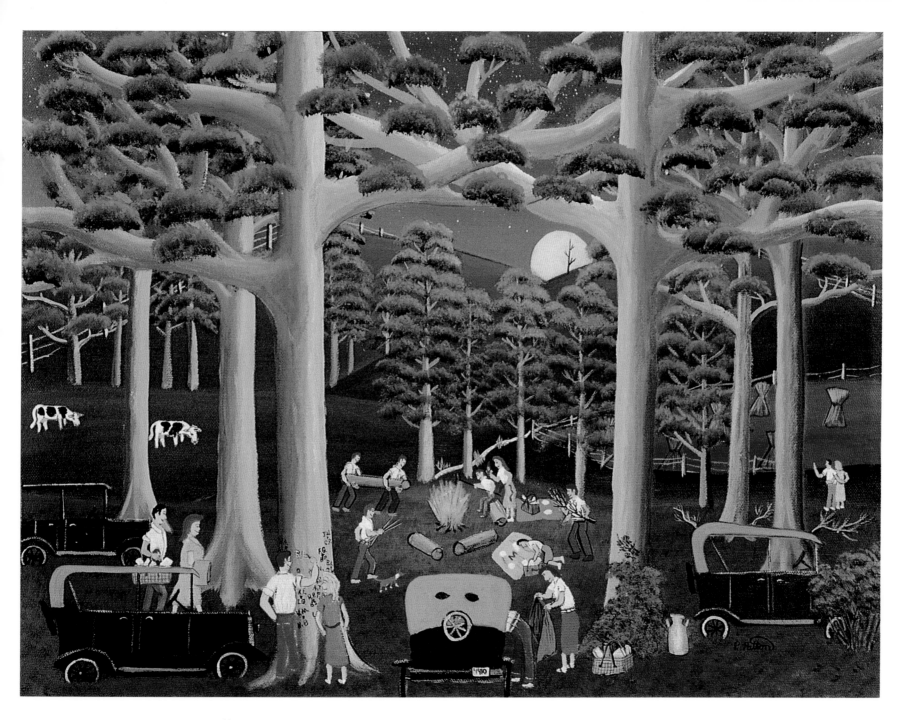

Wiener Roast at Mooreheads. 14" x 18", 1991, #257. Courtesy of Joseph Rait.

October in Rix Mills

The trees turned gold in October, and the air in the village hung heavy with the smoke of bonfires and the pungent odor of burning leaves and brush as the yards and nearby farms were made ready for winter. Nuts were ripe for gathering.

On Saturdays I would take a gunny sack and walk to Emery Watson's woods to gather black walnuts. The ground beneath the trees was dotted with nuts. I filled the sack with as many as I could carry. When I got home I sat on the grass by the gully back of our house and hulled the walnuts. The outer covering was loaded with a brown sap that stained my hands. I allowed the nuts to dry for a week. Then, with the help of aunts and uncles who no longer lived in Rix Mills, I sold them unshelled in Cambridge, New Concord, and Zanesville.

Shagbark hickory nuts were smaller but easier to free from their hulls and easier to crack open. Chestnuts were fairly scarce. Ben St. Clair had a tree close to our house, and Pete Henderson had one about two miles away. I gathered chestnuts in a mop bucket. They were encased in a prickly burr that opened easily when they were ripe . . . but I seldom waited until they were ripe. By the end of October every boy in Rix Mills school from third grade on had brown walnut-stained hands sore from pricking chest-nut burrs.

By that time we were planning Halloween tricks. Halloween in Rix Mills meant tricks, no treats. Dried shelled corn was thrown on porches, and corn cribs and out-houses were toppled over.

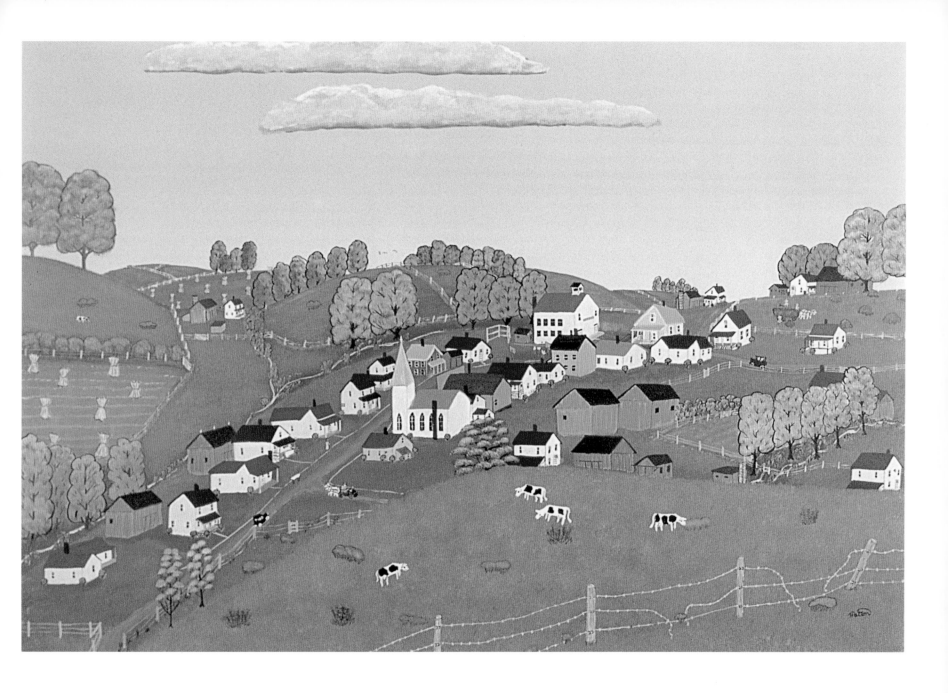

The Village in Fall. 24" x 36" on masonite, 1989, #173. Courtesy of Grace Erin Garrity.

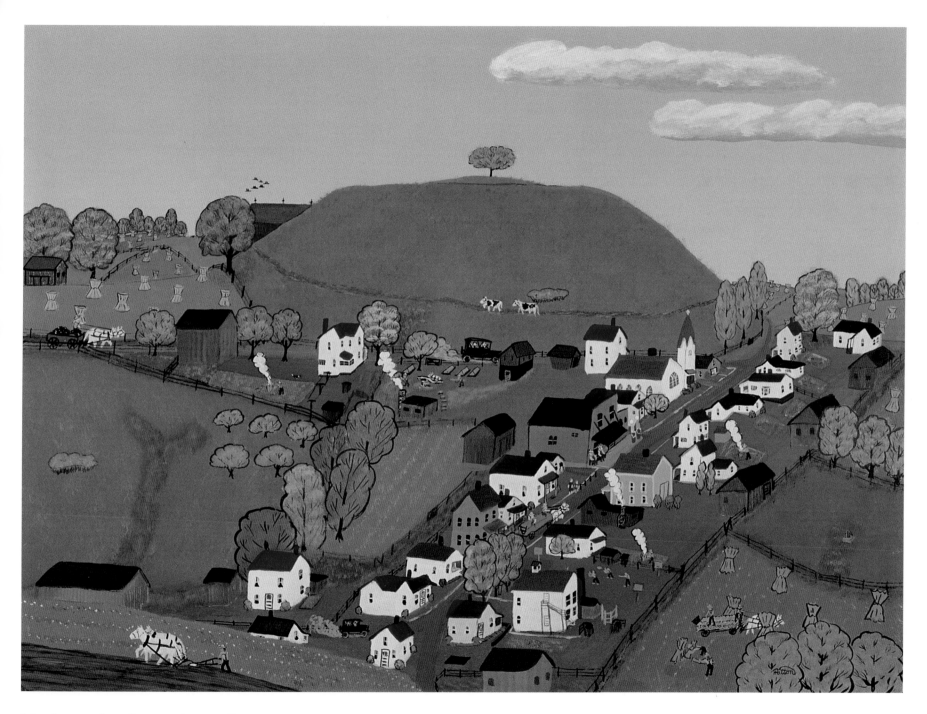

Indian Summer. 18" x 24" on masonite, 1989, #171.

The Chicken Roast

One Friday evening when I was in fifth grade, six of us walked out to the old Mentier place, abandoned for years, for a chicken roast. We got the idea from Irvie Patton, then an eighth grader, who had read somewhere about covering a chicken and potatoes with clay and then roasting them in the ashes of a bonfire. We liked the idea.

Kenny and Myron Elliott furnished the chicken, which their mother, Jeanette, had killed and dressed for cooking. Hap and Dick Aitken brought bacon, and I brought store-bought bread. Irvie brought potatoes and the know-how.

There was plenty of brush for the bonfire we built beside a creek on the deserted farm, well away from any farmhouses. We dug mud from the creek bank and smeared it over the chicken and potatoes. Then we deposited our feast in the fire and waited for it to roast. This turned out to be the high point of the evening. When we pulled the chicken from the fire, it was evident our mud had not been clay.

We never told anyone about the failure, but somehow our families found out. We held our second and last chicken roast on a cold night in November in an abandoned coal miner's shack on Leland Watson's farm. But this time we brought chicken and dumplings from home. We gorged ourselves and sat around the fire and told jokes and stories.

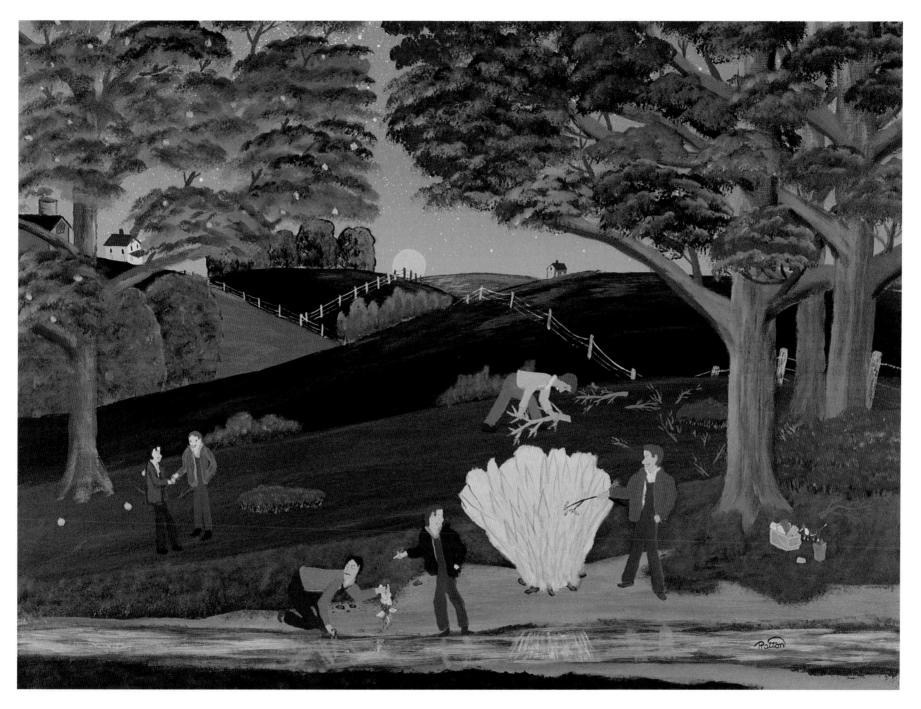

The Chicken Roast. 17" x 24" on masonite, 1988, #132.

Hunting

Hunting and trapping season began in late November. It was expected and accepted that the older boys in the Rix Mills grade school and most of the two-year high school boys would be absent on the first day of hunting season. We hunted and trapped for food and cash, though the time came when I put my gun away, hung up my traps, and never hunted or trapped again.

In those days we set out trap lines in the woods along the creek bank for skunk, though we always hoped for a racoon or a fox. It was skunk we usually caught, and Mr. Monroe invariably had to send us home to get rid of the overpowering skunk odor on our hands and sometimes even on our clothes.

We sold our skunk to Sam Kirk for seventy-five cents, a dollar fifty if the skunk was all black, and Sam sold the fur in Zanesville. I often saw fox tracks in the snow, and though I searched everywhere I never found the fox's den. Sixty years later, I'm glad I didn't.

When I was ten years old I bought a .22 single-shot rifle from John Barnett for fifty cents. I was old enough to hunt with our family 12-gauge shotgun at twelve, and I hunted a few times. Then one November day when I was fourteen I had a sobering experience. I jumped a rabbit, fired, and only wounded it. As I struggled to put the animal out of its misery, and finally had to shoot it again, the rabbit squealed with terror. I went home, put the gun away, and never picked up a gun again until I went to war.

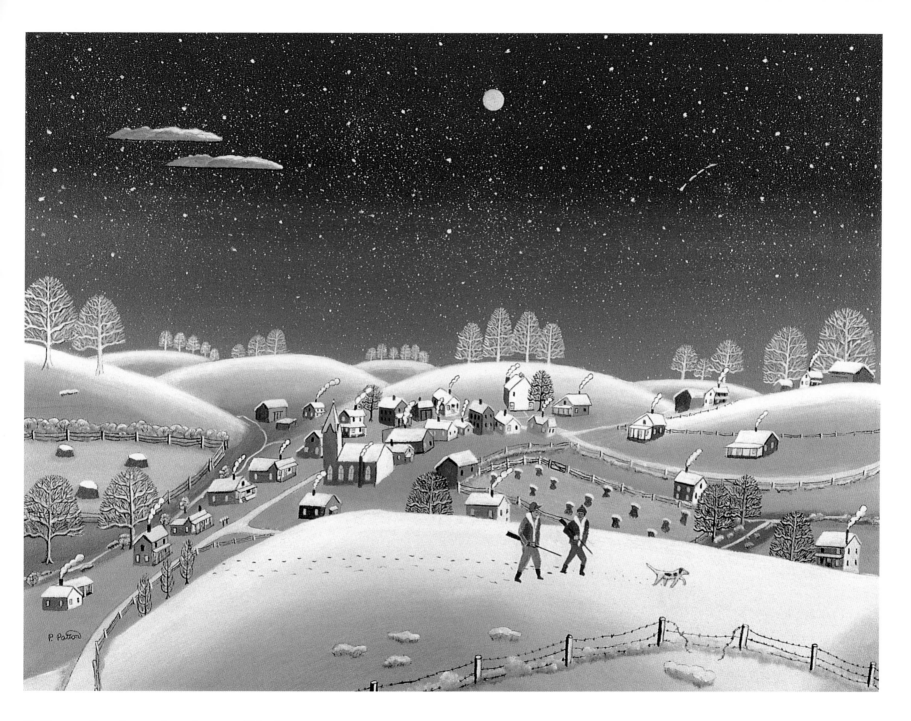

The Hunters. 22" x 28", 1994, #412. Courtesy of John Ong.

The Kirk(e)s

I could never see much sense in coon hunting at night, but Sam and Walter Kirk were hardy souls who took their hounds and braved the dark and winter cold, tramping through snow-filled fields and woods to hunt the shy and elusive coon.

Sam and Walter were bachelor brothers who lived out their lives on the family farm in Rix Mills. Down the hill in back of the Kirk house were the ruins of the foundation of Rix's Mill, the old steam-powered grist mill that the village grew around a half-century earlier and which gave it its name.

Their folks, Jim and Kate, had five sons: Sam, Walter, Harry, Snyd, and Paul. Harry was the Cambridge High School football coach who took my older brother Robert to Cambridge to live with his family and play football. (As a consequence, Robert became the first high school football player in Ohio labeled a "tramp" athlete and barred from playing for a year.) Snyd got his nickname because his best friend's name was Snyder. I never knew his given name.

Several years ago, Paul, then in his eighties, told me that at one time his mother decided it would be nice to add an "e" to the family name. (She had a local reputation as a great reader.) Harry and his wife, Blanche, liked the idea, and so Kirke is on their tombstone in Salt Creek Cemetery in Rix Mills. Beside it is an identical tombstone for Sam and Walter, which reads Kirk. I don't know where Snyd is or how he spells his name, but Paul settled for Kirke. I haven't found Jim and Kate's headstone, but I am sure it says Kirke.

Gathering on Christmas Eve and the Christmas Program

December was a month of anticipation, secrets, and practice for the big Christmas Eve program at the Rix Mills Church. This program was the most joyous event of the year.

On the day before Christmas, Bill Barnett would drive the store truck to Imlay's greenhouse in Zanesville to buy the church Christmas tree. This was a community tree. I knew of no one who had a tree at home. We didn't need one. By that night the tree stood in front of the church, a tinfoil star at the top, decorated with tinsel, strings of popcorn, and paper ornaments. Beside it, a makeshift stage with brown curtains strung on a wire had been arranged.

On Christmas Eve farm families from all over the countryside gathered at Rix Mills Church to celebrate Christmas. Parents brought with them the one Christmas gift each of us looked forward to getting from our folks and placed the gifts under the Christmas tree. Then families filled the church pews, the Sunday school room in the back of the church, and sometimes the aisles to watch their children, grandchildren, nieces, nephews, and neighbor children put on the yearly Christmas program.

Every child had a part. Margaret Barnett selected the songs and speeches and playlets, assigned the parts, held practice, played the piano, and, I am afraid, got little thanks for her efforts.

We wore towels for turbans, tinsel for crowns, and Mary, Joseph, angels, and shepherds were uniformly wrapped in bed sheets. Class by Sabbath-school-class we sang "Silent Night," "Oh, Come All Ye Faithful," and all the old traditional Christmas carols. Applause was generous. The audience suffered with our memory lapses and loved our songs, off-key or on-key. One year my sister Dorothy and I sang a duet. Margaret Tom, with her sweet soprano voice, sang every year.

After the applause for the last act, there was a breathless pause, and excitement grew. Sleigh bells rang outside. Then the doors at the back of the church swung open, and Santa Claus himself strode down the center aisle, a pack on his back. Children acting as his elves helped Santa distribute the gifts under the Christmas tree. Then he opened his pack and gave every child a bag of hard candy from Mr. Monroe, a bag of roasted peanuts from the general store, and an orange from the church. Then Santa hurried away to the soft tinkle of sleigh bells. Another year in Rix Mills had come to an end with that magic night.

Several years after I returned from World War II in 1945, I wore the red suit and played Santa Claus for the children who put on the Rix Mills Church Christmas Eve program.

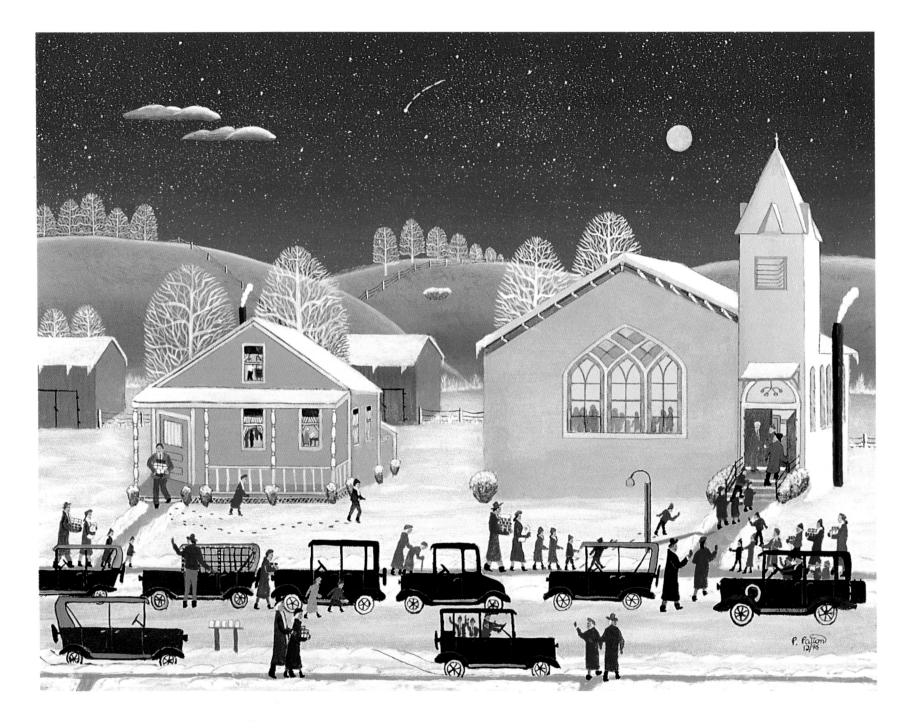

146 *Gathering on Christmas Eve.* 16" x 20", 1997, #519. Courtesy of Wilbur and Harriet Ulrey.

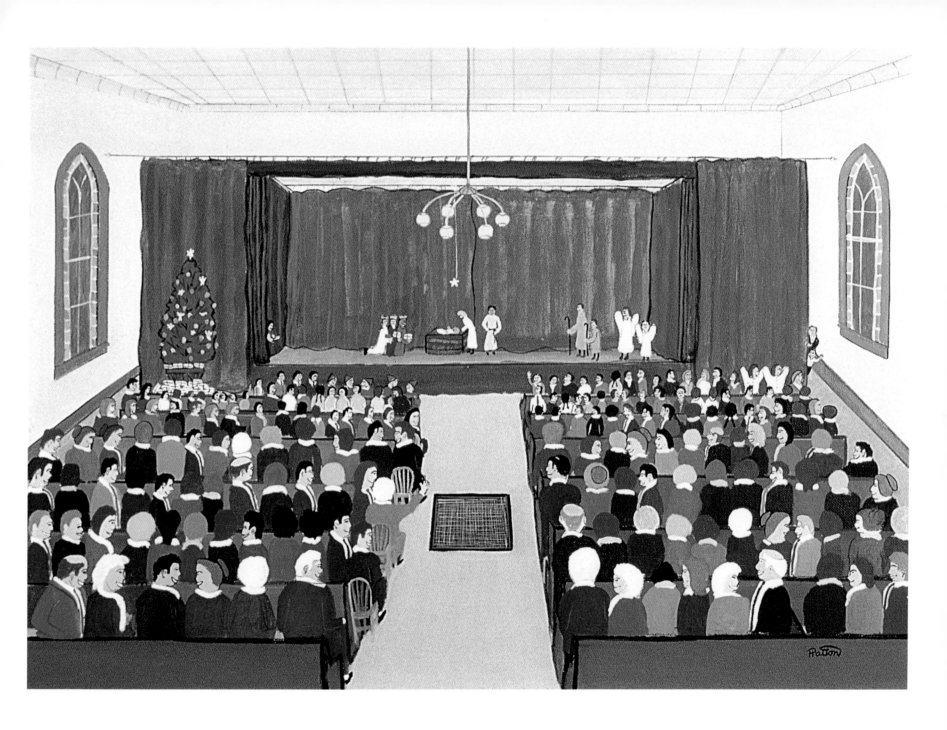

The Christmas Program. 18" x 24" on canvasboard, 1989, #196. Courtesy of the Rix Mills Presbyterian Church.

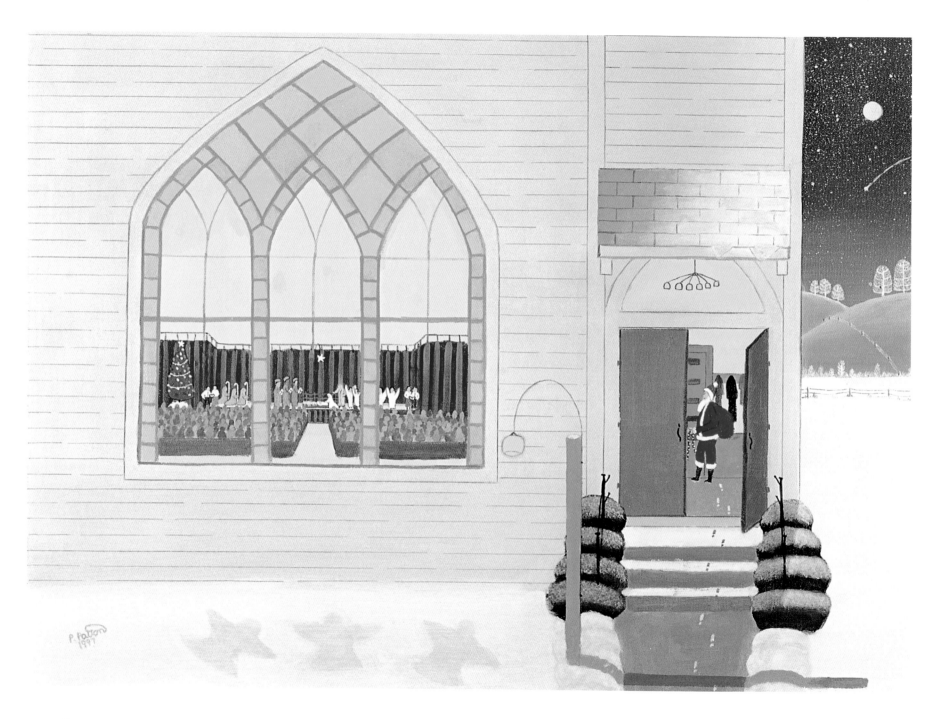

148 *Christmas Eve in Rix Mills.* 16" x 20", 1997, #528. Courtesy of the Rix Mills Presbyterian Church.

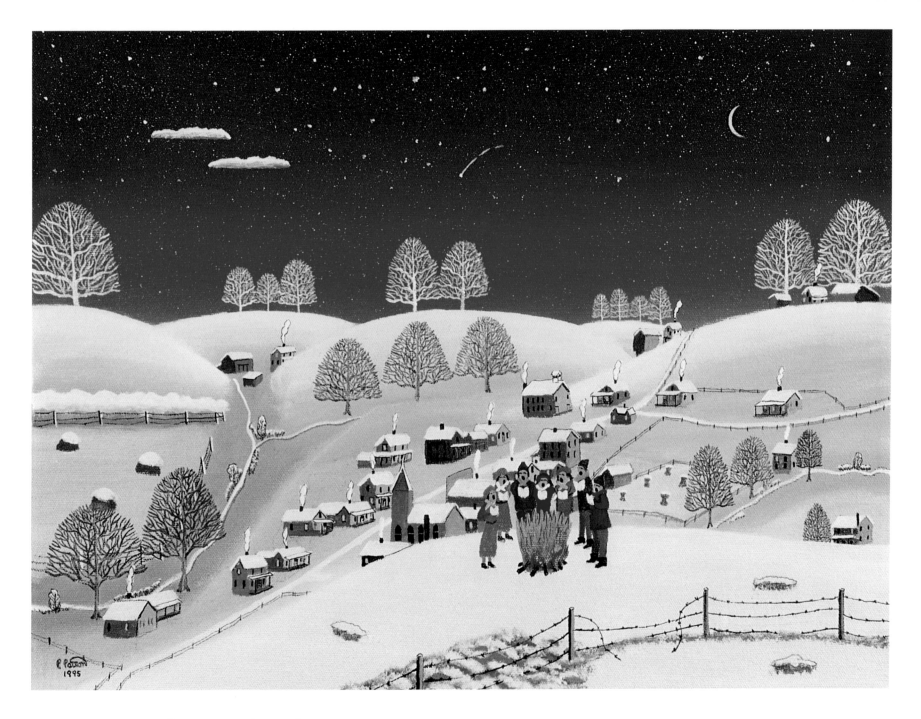

The Carolers. 14" x 18", 1995, #483. Courtesy of Anne Taylor, M.D.

Winter

Snow blanketed the fields and filled the lanes of the countryside from December through March. Most winters brought a slashing blizzard or two to Rix Mills. Shrill west winds bent the trees and whipped the snow in all directions. I never did understand why our dog Rags, a short-haired terrier and an "inside" dog, loved going out in the wildest blizzard. She jumped in the snowdrifts and raced in the teeth of the wind.

Ben St. Clair's hill sheltered us from the worst, but we still stayed in by the stove whenever we could. Once the wind stopped blowing and the snow stopped falling, fields were silent and white. By January drifts often filled the four roads into the village where they cut through the hills, the upper and lower roads to New Concord and Chandlersville. Horses and wagons would handle the drifts better than automobiles. Snow never kept my older brother Robert from visiting his childhood sweetheart Mary Wilson.

Rix Mills was often snowed in and was not overly worried about it. Shoveling by hand, farmers took days to clear the roads. The glare of the sun on the snow was bright. One year I got sunburned shoveling the snow. The mail generally got through. Most winters there were a few days when Fred Booth, our R.F.D. mail carrier, couldn't make it, but no one fretted about it. Mail was neither heavy nor important.

When snow was cleared from the lanes and the roads, life in the village resumed. The store was always

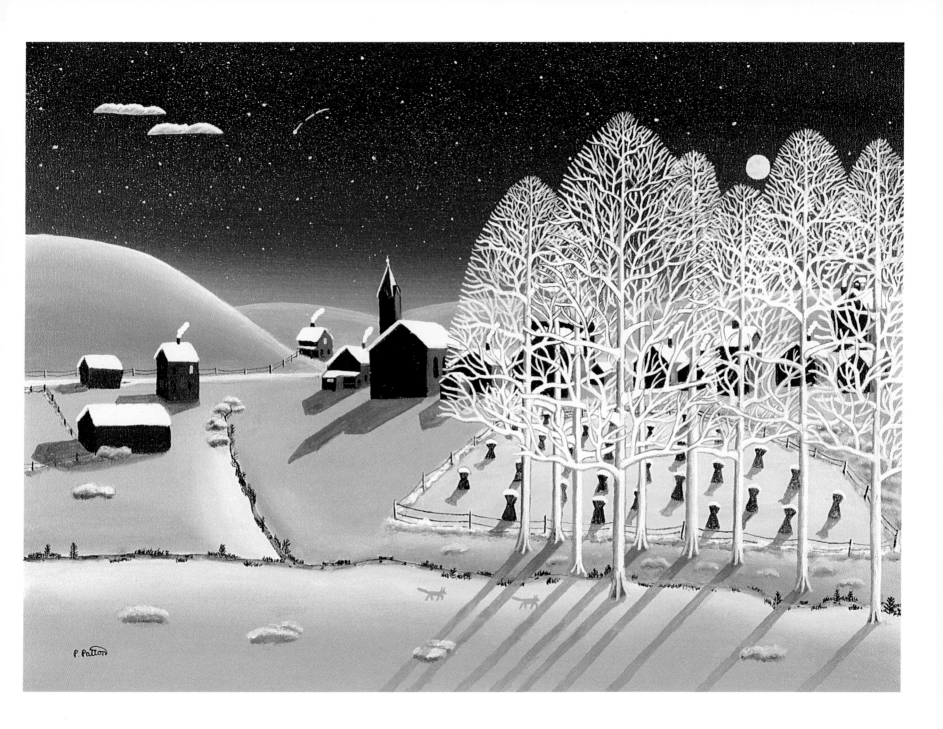

The Hunters. 18" x 24", 1995, #468. Courtesy of Sim Galazka, M.D.

open and frequently busy. Oddly enough, I can't re-member a day when school was closed.

Church was always held, though attendance was down. We didn't have a lot of evening services in win-ter, but when we did men would wrap their wives and children in blankets and load them in their Model-T Fords, a surrey, or in some cases a horse-drawn sledge and bring them out of the snow-covered lanes and gravel roads to the Rix Mills Church. Occasionally in the winter the church choir members would get to-gether at the church on Friday night when Margaret Barnett, the director, returned from New Concord, where she spent the week teaching Latin at the high school. Choir was not something we expected a great deal of as a regular part of the church service. For the most part it was made up of the same people, Sunday after Sunday and year after year.

January Snowstorm. 18" x 24", 1995, #471. Courtesy of June E. Beamer-Patton, M.D.

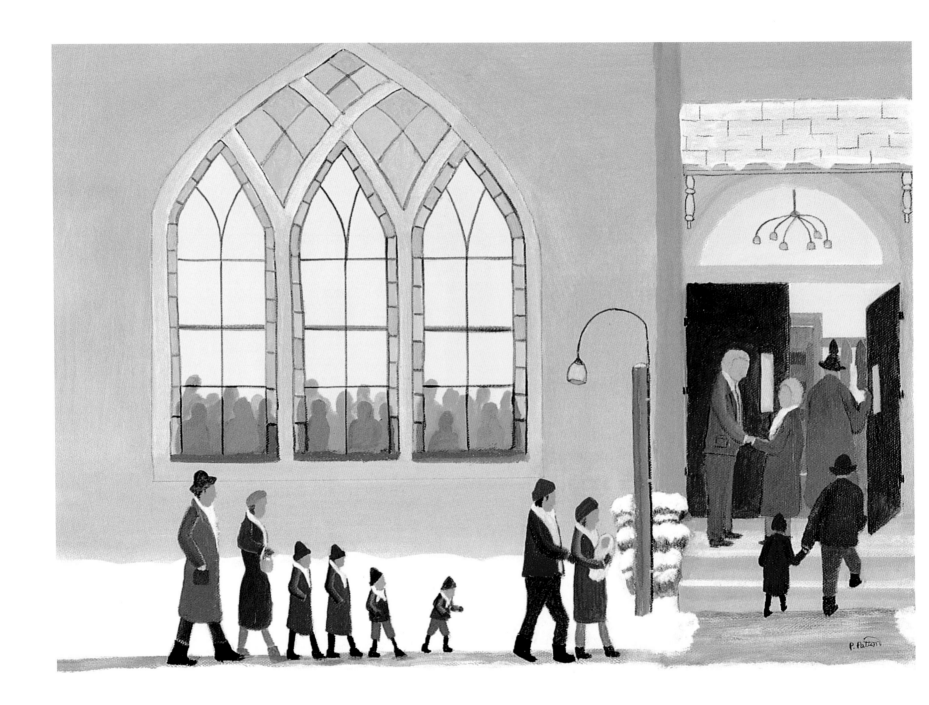

154 *Evening Services.* 14" x 18", 1996, #499.

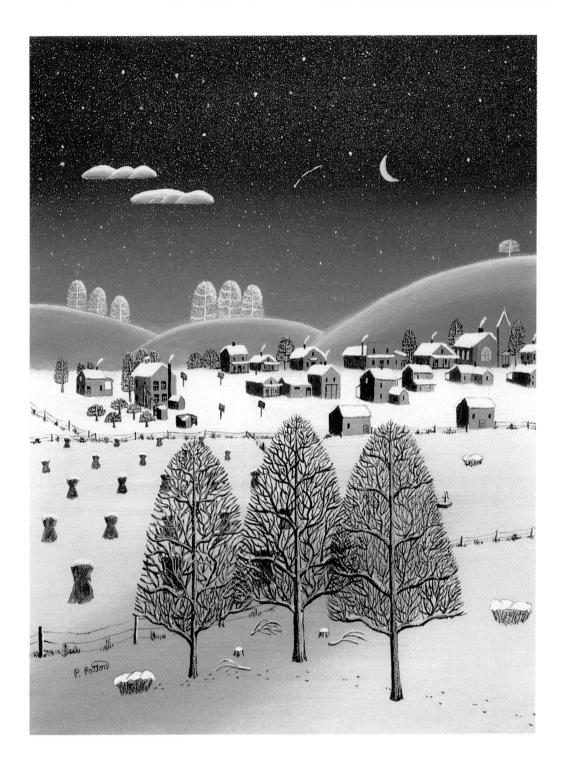

Choir Practice Night. 18" x 14",
1995, #501. Courtesy of John
Blazar, D.D.S.

Winter at Home

At home life centered around the potbelly stove. On a winter Saturday a game of Monopoly with the Pattons and the Glasses might last five hours. We made popcorn in a skillet on our gas stove and drank hot cocoa. We read by the glow of gaslight, slept under great piles of quilts and comforters in cold bedrooms, and went outdoors to colder privies.

We had the Tom Swift, Harold Bell Wright, and Gene Stratton-Porter books at home, and we raided Uncle Johnny Campbell Watson's closet for the Tarzan and Zane Grey books. Marion and Robert bought records and played them on our wind-up Victrola. My mother sewed on her treadle machine for the girls, herself, and sometimes other people.

Hams and bacon hung in our smokehouse. We kept milk in the basement and skimmed cream off the top to make butter. Crocks of lard and a winter's supply of potatoes, picked on the share in the summer, were stored there. Our basement shelves were lined with mason jars of canned cherries, berries, tomatoes, spiced pears, pickles, and more that my mother had spent all summer canning or cold-packing. Canned pork tenderloin was a particular delicacy, though we grew tired of the pork and ham we ate all winter. An Elliott uncle always butchered the two pigs we raised all year, one for our family and one for his. Navy bean soup was often on our table.

Milking was a miserable chore. The cow's whiskers under her chin froze as she stood in the cold barn. I rubbed my hands and ears to keep them warm. Windows frosted on the inside, and clothes froze dry on the clothesline. We drained our pump at the kitchen sink at night and primed it in the morning.

In the countryside farmers chopped ice from the watering troughs and lit newspapers with a match to thaw their cistern pumps. Farmers climbed high in their barns to the haymows, pitched their hay down to the stalls, and then carried it to the mangers. They husked their corn by hand on the freezing barn floor and fed the ears of corn through the hand-operated corn sheller, then mixed the corn with wheat or oats from the granary bins and carried it to the feeding troughs.

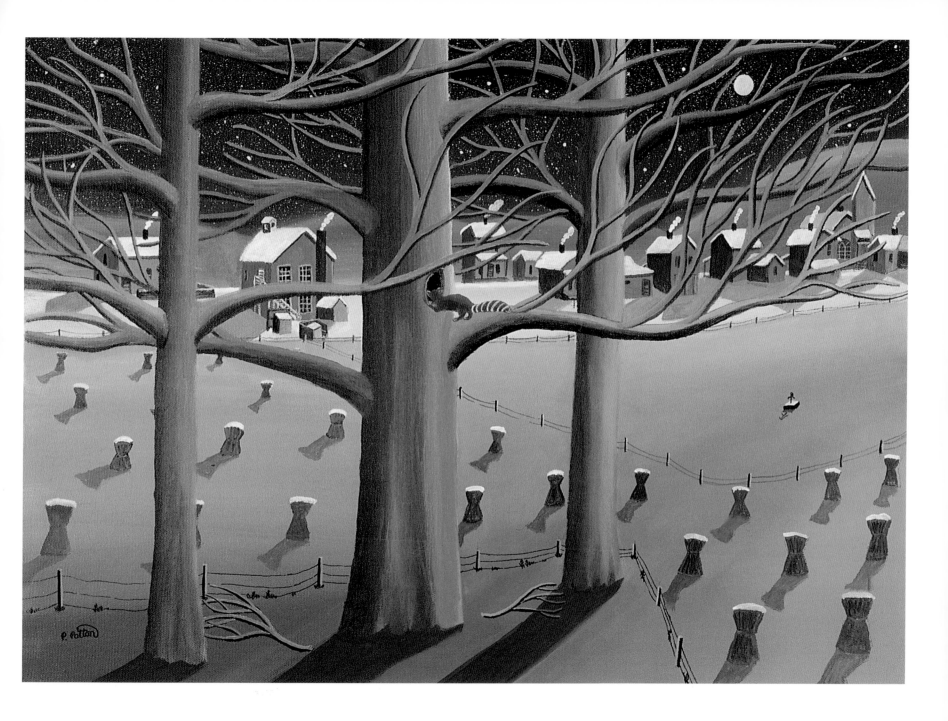

A Long Winter's Night. 18" x 24", 1995, #470. Courtesy of William Lightbody.

Taffy Pulls and Ice Cream Parties

On long winter evenings we sometimes had a taffy pull or an ice cream party. Young friends of approximately the same age would gather at the hostess's home for gentle gossip and news, some stories, games, and, of course, the taffy pull.

Taffy was made by the girls, who boiled sugar and sorghum molasses together and added a little vinegar at some point. They cooled the result until it could be pulled and then worked into beige-colored ropes and set outside to harden. Then it was cut into sections and chewed . . . and chewed. It wasn't very good taffy, but it was a good excuse for boys and girls to get together.

More fun were the ice cream parties we had in the winter. Generally a brother (but in emergencies a father) would journey to the nearest creek and hack out a gunnysack full of ice. The hostess would have cooked the custard, rich and yellow with cream and eggs, before the party. Again, the news and gossip and games. Then the boys would turn the freezer, and finally the sharing of great dishes of ice cream along with a choice of cake or fruit pie. Much better than sorghum taffy!

My sister Dorothy and I were always the youngest at the taffy pulls and ice cream parties Marion and Carol held in the winter.

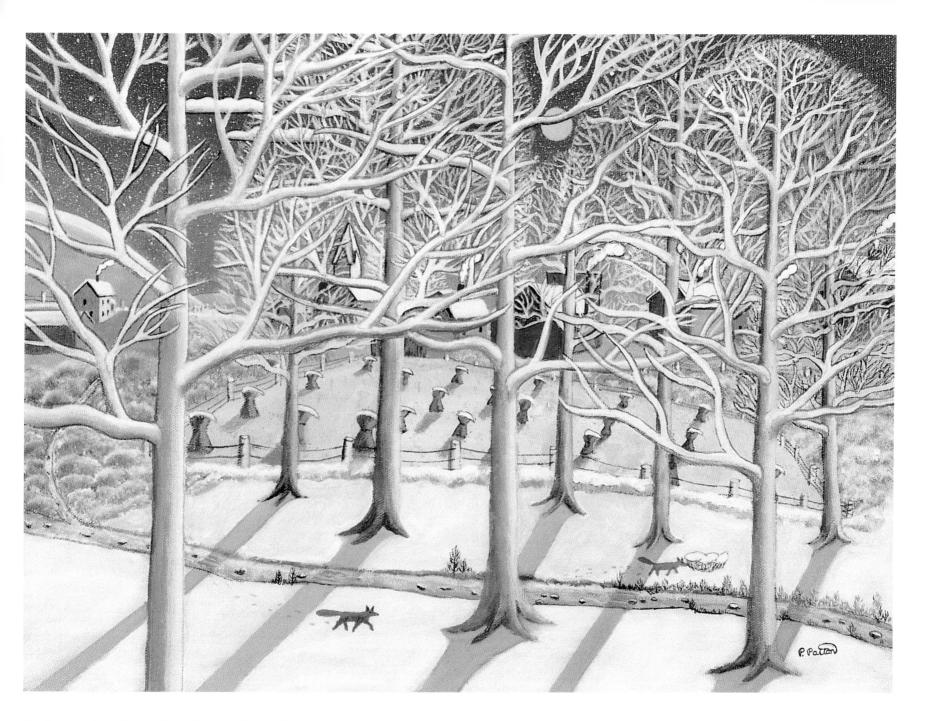

The Hunters. 14" x 18", 1993, #389. Courtesy of Karen Skunta.

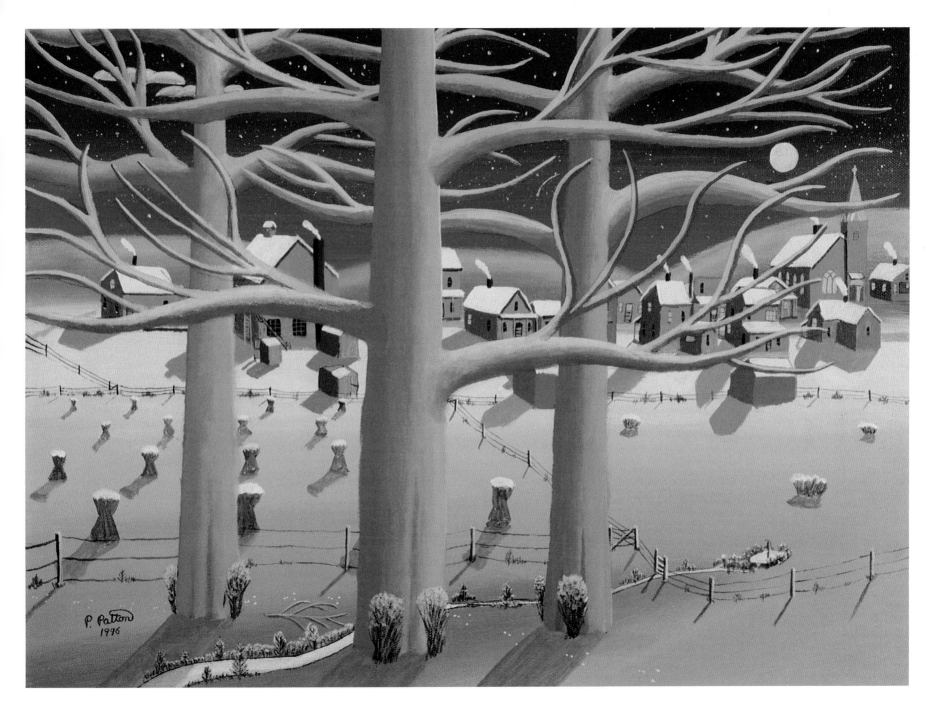

Zero Night. 16" x 20", 1996, #517. Courtesy of Dennis Friedman.

Building the Fire

My most important job as school janitor was building the fire in the big stove in the grade school classroom in winter, early in the morning, long before the teacher and the children arrived at school.

On a winter morning I got up at 5:30. It took only minutes to pull on a shirt, sweater, and bib overalls over long underwear and hurry downstairs with my socks and shoes to the warmth of the potbelly stove. Breakfast was my mother's boiled wheat with sorghum molasses. By six o'clock I had my lunch bucket with fried egg or ham sandwiches in my hand and was on my way to school.

I walked the quarter mile to school in the snow and winter darkness. Even the roosters and dogs were still asleep. The only sounds I heard were the whispers of the biting wind and the crunch of my footsteps in the snow.

The big old building was never locked, and I was always a little afraid to open the door. Inside the school was dark, cold, and full of mysterious creaks and rattles. I don't remember lighting a gas lamp, so I must have worked in the dim light from the big windows. If I was lucky, there were still embers glowing in the old stove. But sometimes the fire I had banked the evening before had burned out, and then I had to shake the ashes and cinders from the fire box, get kindling wood and newspapers from the coalhouse behind the school, and build a new fire. On those days we wore our coats till midmorning and sat on benches as close to the stove as we could get. When Mr. Monroe came he took care of the furnace the rest of the day.

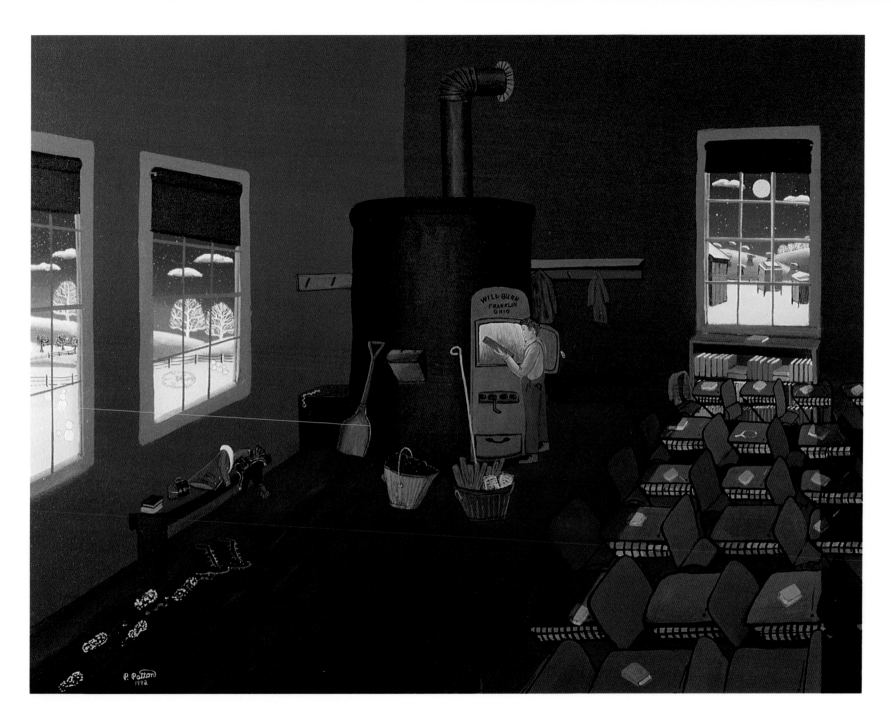

Building the Fire. 24" x 30", 1992, #356. Courtesy of Ellen Rothchild, M.D.

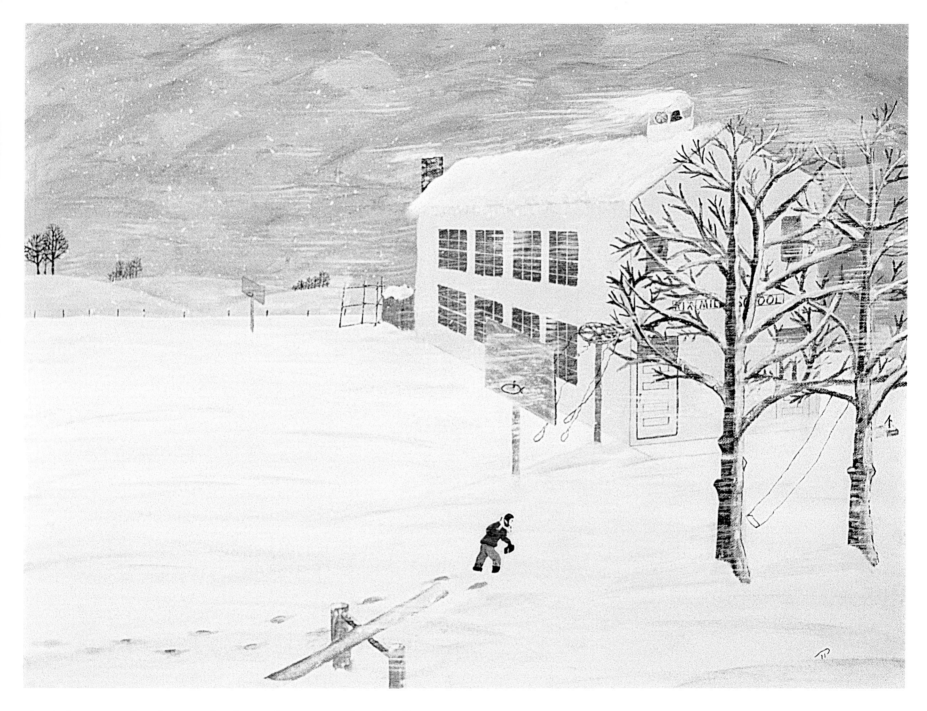

The Schoolboy Janitor. 18" x 24" on canvasboard, 1986, #31. Courtesy of Dorothy Abbott Patton.

Sledding

When winter snows covered the school playground, recess was pure joy: snow forts, fox-and-geese games, snowballing, washing others' faces with snow, and sledding on the road in front of the school, where only an occasional horse and wagon went by.

We had an hour at noon and spent little time on our lunch at our desk or on a bench close to the stove. We liked to take our sleds across the road, cut through John Barnett's yard, and open the gate to Joe Grimes's farm field. Then we rode our sleds down the hill into the Grimes's barnyard.

Many people didn't have sleds or lived too far away to bring a sled to school, so Mr. Monroe built a toboggan for the school. It was a stout wooden sled that held five or six. The younger ones sat straight up, held tight, and generally made it all the way down the hill. But the sled had a high center of gravity, and the older ones could tip the sled over if they leaned sideways. This happened often, and it was usually not accidental.

The first heavy snowfall sent us out to the barns, sheds, and, in our case, the coalhouse for our sleds and then racing to be the first on Ben St. Clair's big hill. My cousins Myron and Kenny Elliott had flexible fliers, long sleek sleds that swooped down the hill and turned easily. We doubled and tripled on those sleds, but it was a hard ride for the sledder at the bottom of the pile when we hit Ben's cow path. Bill McCormac skied on barrel staves, or tried to. The Pattons had a family sled we steered by dragging a foot for a belly whopper or leaning at a 45-degree angle when sitting up.

Steering the sled was very important because there were hazards on every hill. The road in front of the school curved, and unwary sledders could end up in Mary Ray's fence. Sledders on Joe Grimes's hill had to steer sharp right, at full speed, around Joe's house and then curve left away from his chicken house and through the gate into his barnyard. Ben St. Clair had barbed-wire fence hard around at the foot of the hill.

One day I found a discarded sheet of corrugated steel roofing in the trash under the general store and bent one end in a reasonable copy of a toboggan. Joe Glass and I took it up Ben's hill for a tryout. It was hard to start, and took a lot of pushing by both of us. Then when we got to the steep grade, the roofing took off like a wounded bull. There was absolutely no way to guide the thing, and as we whizzed across the cow path near the foot of the hill we realized that we were on a high-speed track headed straight for the barbed-wire fence. In perfect unison we lay back flat and zipped under the lowest wire. The roofing went back into the trash.

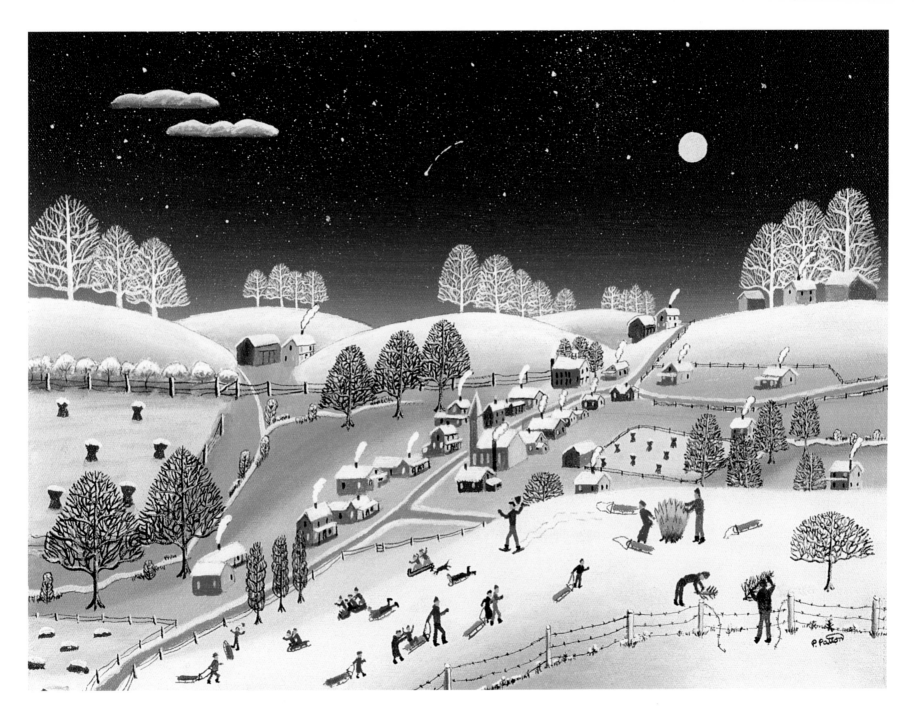

Sledding Party. 14" x 18", 1995, #463. Courtesy of James and Joan Bissland.

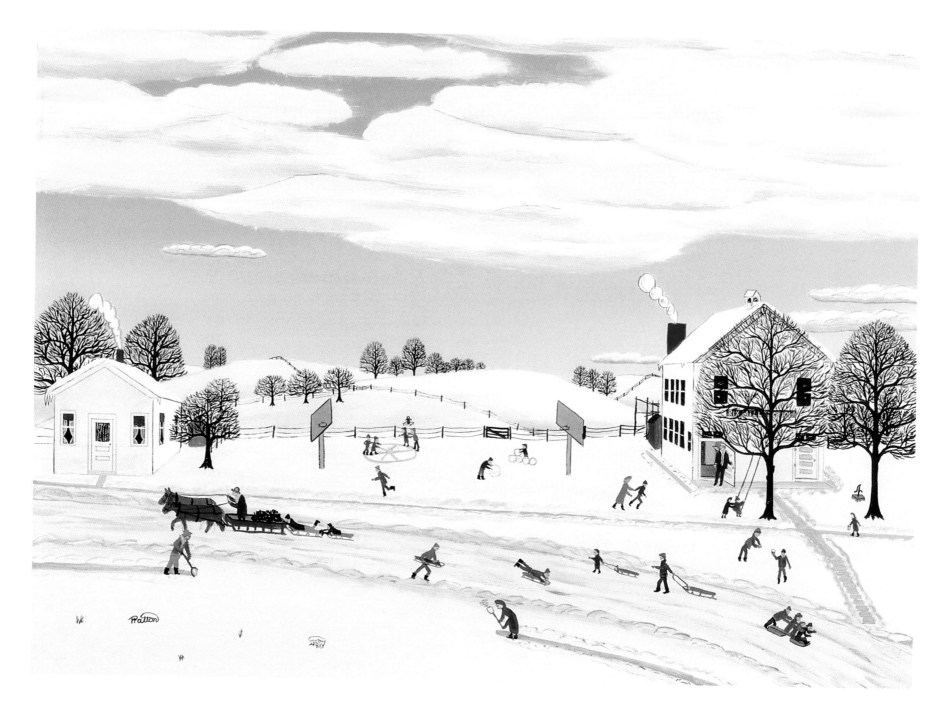

168 *December Recess.* 18" x 24" on masonite, 1989. #189. Courtesy of Joyce Patton Fellows.

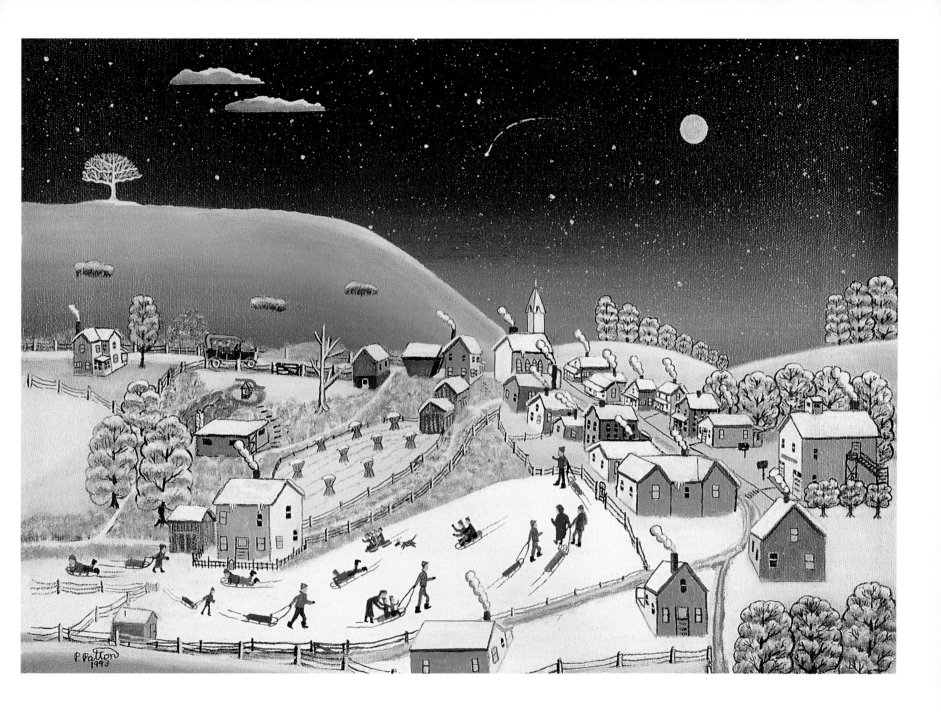

Holiday Memories: Sledding Joe Grimes's Hill. 13" x 18", 1993, #359. Courtesy of Margaret and Richard Wenstrup.

Green Valley School

Green Valley School was three miles down the lower road to Chandlersville. A beautiful little white one-room school, it was one of ten one-room schools in Rich Hill Township in the 1920s. It stood on a farm field in a forest setting. It had too few pupils for a ball team and too little ground for a ball field, so we knew little and cared less about that pretty little school.

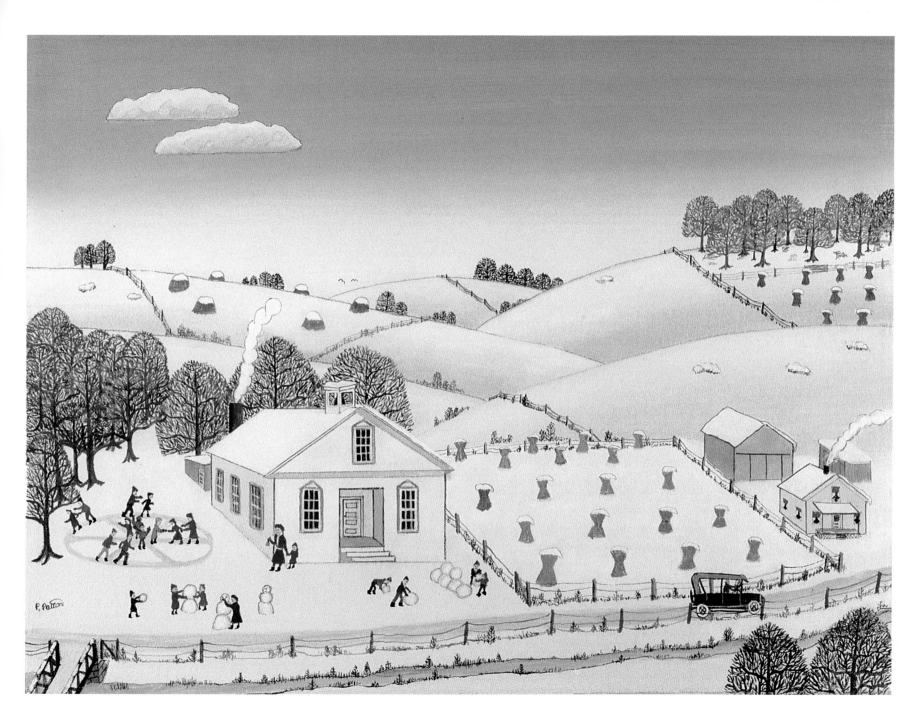

Green Valley School. 18" x 24", 1993, #381.

The Loafers

On a snowy afternoon or a cold winter night when the roads were good enough to get to town, the chairs and benches around the potbelly stove in the general store were filled with loafing farmers. These were lazy times for the exchange of stories and munching on cheese and crackers, washed down with some soda pop.

While the store did not serve food, the storekeepers kept an open box of crackers to go along with the cheese or sardines or weenies a loafer might buy. One day I was watching Pete Miller eat a cheese and cracker sandwich when Johnny Campbell Watson asked me if I would like some crackers. I said yes, and he said I could have the rest of the box if I could eat them all without drinking water.

I started with great glee, but soon had the driest tongue in the township. Johnny Campbell and the farmers laughed loud at my efforts, and then he gave me my favorite soda pop (cream soda). He nicknamed me "Cracker," and the name stuck all the way through New Concord High School. Johnny Campbell nicknamed my brother Ralph "Beanie," too, and that name stuck for life. His wife never called him anything else.

Jim Ledman, one of the store's two proprietors, was a big man, somewhat reserved, and highly respected. He was a community leader, a college graduate, and president of the school board. Johnny Campbell Watson, the other proprietor and my uncle, was a World War I veteran, outgoing, full of jokes, and widely liked. The only thing the two men had in common was the habit of chewing tobacco. Even here they were different: Jim spit on the floor, while Johnny Campbell, with unerring aim, used the spittoons located strategically around the store.

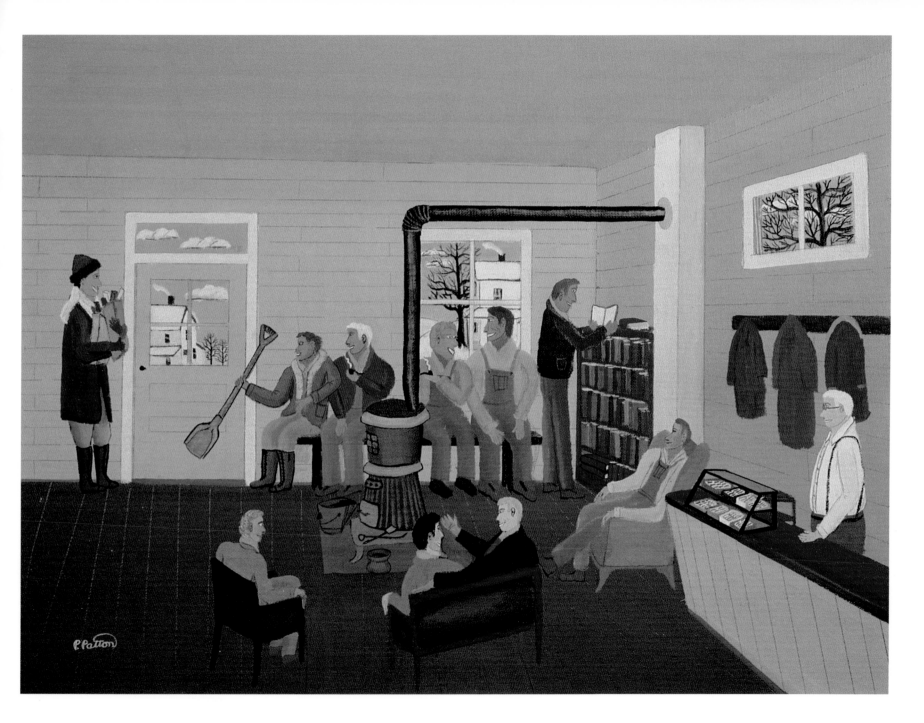

The Loafers. 18" x 24" on canvasboard. 1991, #306. Courtesy of Dorothy Abbott Patton.

Frank White's Farm

Frank White's farm stood strong and alone on the upper road to New Concord. No lights showed along the way at night to mark farms and neighbors. Whether we were going to or coming from New Concord, Frank White's farm stood sharp against the night sky and told us we were halfway there.

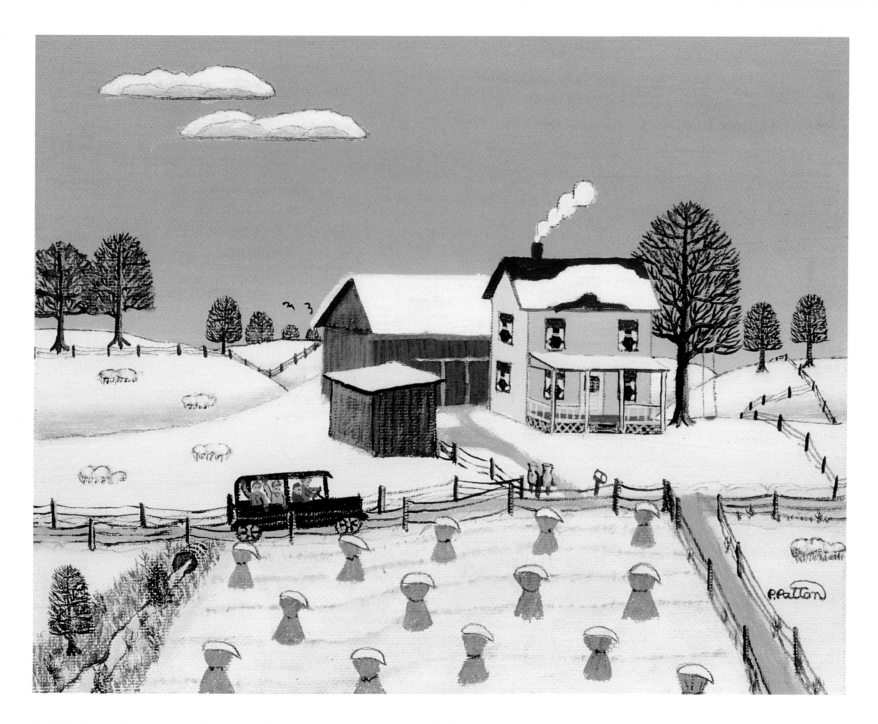

Frank White's Farm. 8" x 10" on canvasboard, 1992, #336. Courtesy of Margaret and Richard Wenstrup.

Pig in the Parlor

Pig in the Parlor was a square dance game we played when the Young People's Society held its evening party in the two-year high school classroom on the second floor of the Rix Mills school. That's the game I remember best.

We lit the chandelier, piled the desks on one side of the chalkboard-lined room, and set a punch jar and plates of homemade cookies and cakes on a table at the back of the room. We always boasted that we would play Spin the Bottle, a kissing game, but the truth is we didn't.

Margaret Tom would play the piano to the tune of "The bear went over the mountain," and we danced around whoever was It singing,

Oh, we've got a pig in the parlor, and he is Irish, too.
Oh, the right hand to your partner, the left hand to your neighbor,
And all promenade.

The pig could break into any couple, and then we all sang "We've got a new pig in the parlor." (The words were from an earlier century, and they didn't bother us; we were all Scotch-Irish.)

Many of us were shy and awkward. There were tall girls and short boys who hadn't begun their real growth yet. There were eighteen year olds, twelve year olds, and occasionally younger brothers and sisters who had come along.

We always had a swell time—"swell" was a favorite word then.

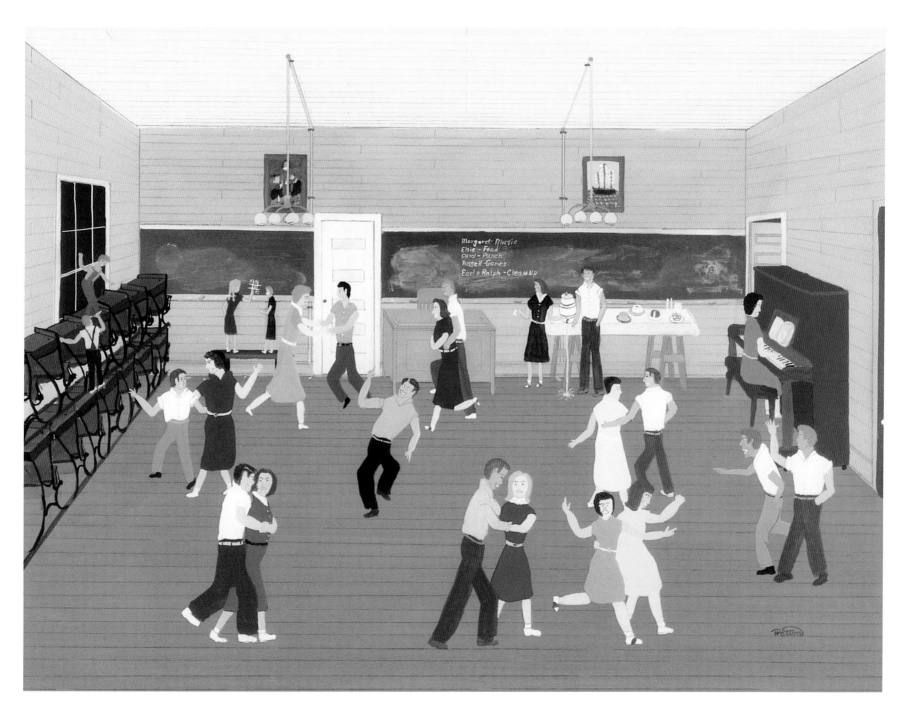

Pig in the Parlor. 18" x 24" on masonite, 1988, #110. Courtesy of Dorothy Abbott Patton.

Loading the Team

When March and April came and the winter snows finally began to melt, we put away our sleds and waited impatiently for the imminent end of the school year and for the mud on the playground to dry enough to play softball.

Every spring Mr. Monroe scheduled a couple of games with nearby Westland and Rich Hill schools. When we were playing an "away" game, he closed school early and twelve or fourteen upper grade boys and girls piled three or four deep into Mr. Monroe's big black touring car for the ride. He usually parked in front of the Barnetts' house up the road from the school, where the road was a little wider.

A ball game with Rich Hill was always scheduled for our last-day-of-school celebration. Rich Hill was a big grade school: it had two classrooms, and strapping big boys, seventh and eighth graders, were on the team. Our team was about half girls. This gender gap was considered a handicap, but we won about half the time.

Hap Aitken and Myron Elliott were the stars. Dick Aitken and I got in for an inning or two after the outcome was decided.

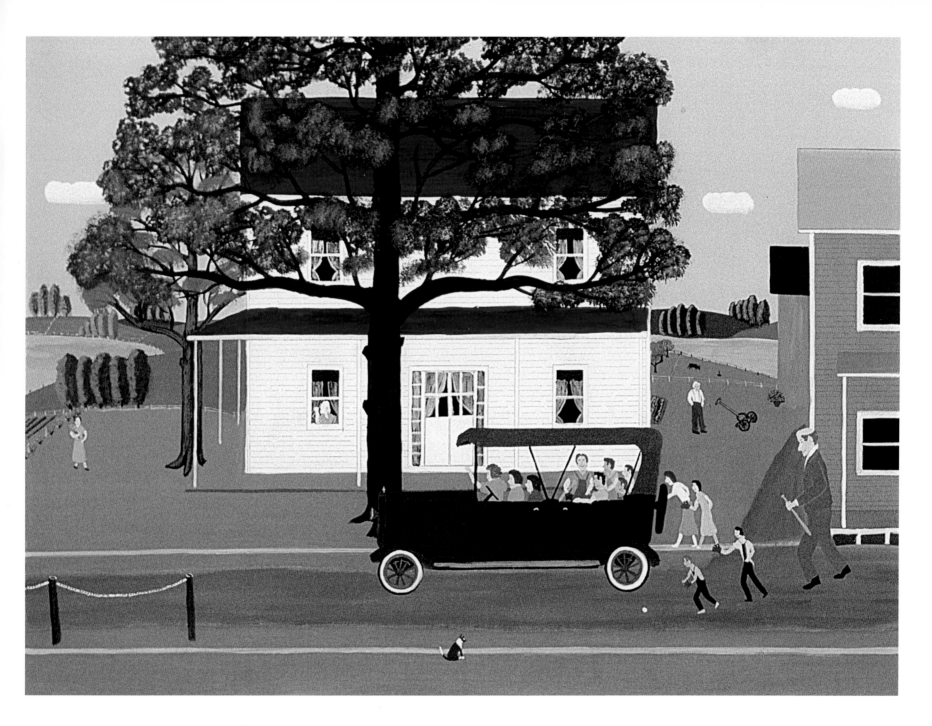

Loading the Team. 18" x 24" on masonite, 1988, #105. Courtesy of Rainbow Babies' and Children's Hospital, Cleveland.

The Last Day of School

Along about the February thaw, we started longing for the last day of school. But the last-day-of-school celebration wasn't really the last day of school. With ten one-room grade schools in Rich Hill Township and almost everybody in the township related by blood or marriage—or at least very close friends and euchre-playing partners—these last-day-of-school celebrations had to be carefully scheduled. School might last three more weeks, but we were always out in early May.

In the morning all mothers, many grandmothers, a few fathers, and Jim Ledman, president of the school board, came to school. We had stacked half the desks in the cloakroom and set up chairs borrowed from the church in the back of the classroom. Then we doubled up in the remaining desks, and Mr. Monroe conducted an abbreviated schedule of class recitations. His questions were always easy that day, so we were never shamed before our folks.

Lunch was potluck, served by our mothers on plank tables in the front yard of the school. Then there were athletic contests—sack races, dashes, ball throws, and high jumps. The big event of the afternoon was the softball game with the visiting Rich Hill team. They always arrived looking deadly serious, limbering up by swinging their bats in great circles and tossing the ball around in a highly professional manner. They were serious competition for us, even though they were our cousins, fellow 4-H Club members, and church friends. They usually won that game.

In the evening we had a program on the stage at the church. Mr. Monroe would select a play from a catalog sent out by a publishing company. The school board bought enough copies for the big parts, and Mr. Monroe would write out the smaller parts by hand. The play was the big draw, the feature, but there were lots of speeches, poetry recitations, and songs. Every student had a moment before the crowd, and it was a big crowd. The audience never disappointed us. They laughed and clapped and cheered.

Then, when the last day of school did arrive, we joined the countryside in preparing for the summer ahead. We were needed. It took all of us, young and old working together, to care for our farms and animals, to plant our gardens and fields and cultivate and harvest them. None of us had any idea how much the world would change in a short time.

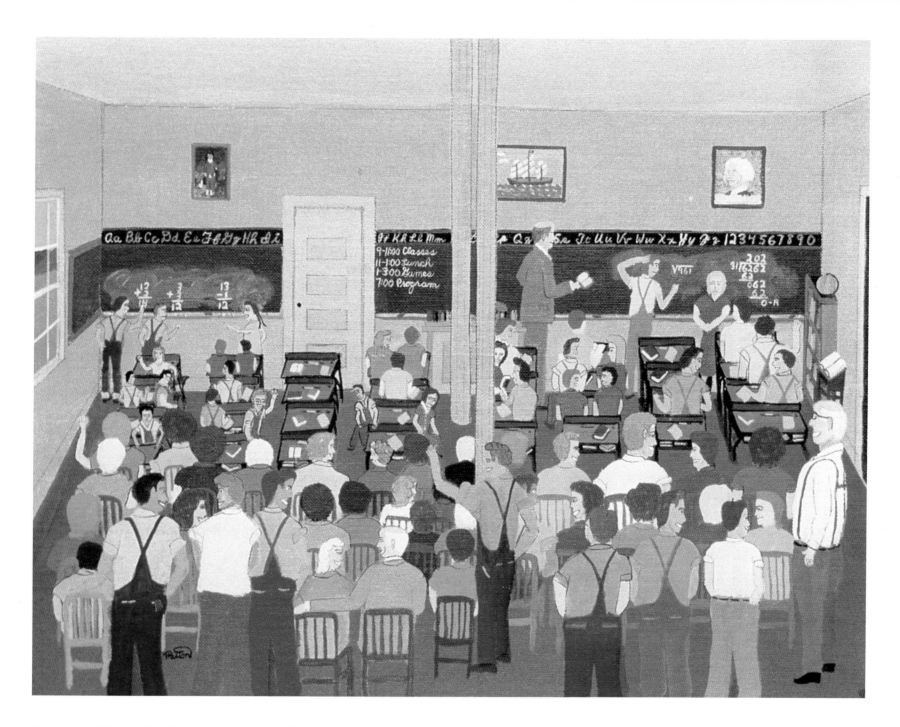

The Last Day of School. 14" x 18" on canvasboard, 1989, #154. Courtesy of Dorothy Abbott Patton.

Changes

The life we lived in Rix Mills in the 1920s and early 1930s was much like the life our parents had lived. But change was coming.

Teams of horses still pulled wagon loads of hay and wheat and sorghum through town. But by the end of the 1920s the blacksmith shop was closed and most farm families had Model-T Fords. Families could drive to New Concord to see the doctor and to Zanesville for business and shopping. The hitching posts in front of the general store were not used much. Only Billy Copeland still used the mounting block in the church yard when he rode his horse to church. The Glass boys had crystal radio sets, and the Gregory boys far out in the township had set up a Delko electrical system for their farm.

Carol was the last of the family to go to the Rix Mills two-year high school and on to Rich Hill to graduate. Ralph, Dorothy, and I rode the yellow school bus to New Concord High School. Not long after, the one-room Rix Mills grade school closed and township pupils were bused to New Concord. At about the same time the power company began buying land and strip-mining the region.

Many of the people in the Rix Mills paintings lie in Salt Creek Cemetery, overlooking Rix Mills. In 1986 the church celebrated its 150th anniversary as a congregation. The pastor is now Reverend Roland Steele, who divides his time between the Rix Mills and Cumberland churches.

Central School, Bedford, Ohio: Memories, 1967–1982

I got my first school job when I was ten years old in fifth grade as janitor of the Rix Mills grade school classroom. I got my last job thirty-four years later as principal of Central Elementary School in Bedford. I liked recess best of all at both jobs. As principal I spent most recesses with the children on the playground. There I got to know them and they got to know me in a generally mutually happy situation.

After I retired from the Bedford schools, I became an untrained artist painting my memories of my boyhood years in Rix Mills, Ohio. In 1996 the Bedford Historical Society asked me to paint Central School. Naturally I painted recess on the playground.

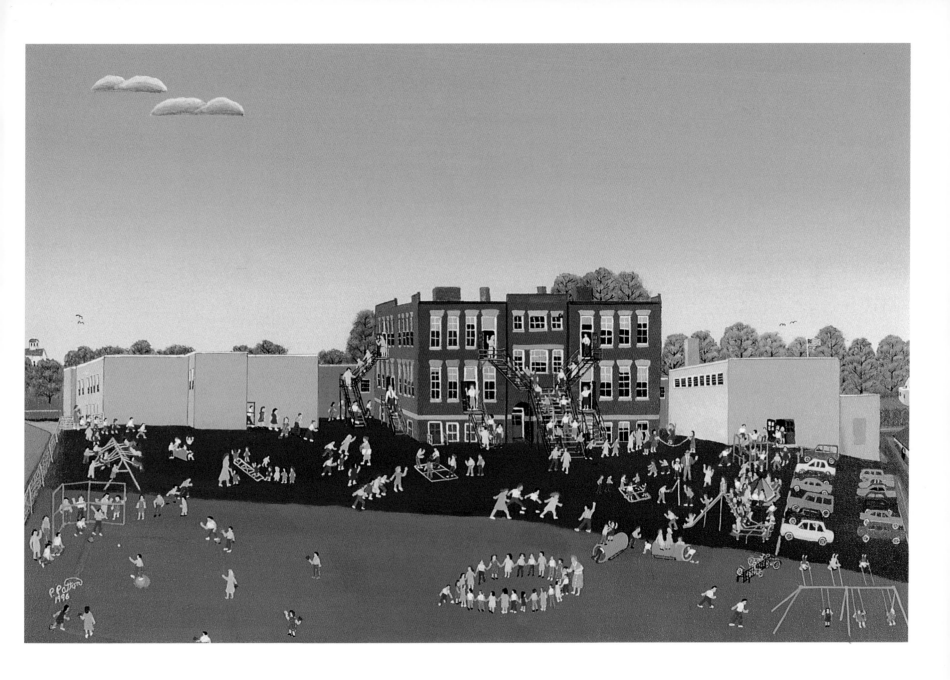

Central School, Bedford, Ohio, Memories, 1967–1982. 20" x 30" acrylic on canvas, 1996, #505. Courtesy of the Bedford Historical Society.

Afterword

by Dorothy Abbott Patton

A winter storm swept in the day Paul W. Patton died in University Hospitals of Cleveland, twelve days after Christmas 1998. The blizzard brought statewide travel to a halt.

His family and Central School teachers, parents, and friends gathered in a historic old church in Bedford Commons on a snowy Sunday afternoon in February to remember him. And then on a blue-sky spring day in April, the Saturday after Easter, family, friends, and relatives came to the church in Rix Mills for a memorial service. Reverend Ellen Thomas conducted the service, Margaret Tom West (who plays piano in the *Pig in the Parlor* painting) played the organ, and the women of the church served a luncheon in the church basement. Pattons, Elliotts, and old friends came from California, Florida, and Pennsylvania. Joe and JoAnn Glass came from Baton Rouge, Louisiana. Family and friends came from the Ohio countryside. Gerry Barnett, the son of Ethel Patton and Bill Barnett, whom she later married, was there.

The tombstone for Paul Walker Patton and Dorothy Abbott Patton lies in Salt Creek Cemetery with the Wils Patton family, close to the road (Route 313). The last of the Ethel Patton family, Carol Carroll, died Thanksgiving weekend 1999.

For nearly half of the twelve years Paul Patton painted in retirement, he was homebound with health problems and on oxygen. During this time he had two holiday-time exhibitions at University Hospitals in Cleveland and became well known to hospital doctors, nurses, and staff as a patient as well as a folk artist. His passion for painting kept him looking forward.

His passion for painting was matched by his devotion to children and the elementary school. At Central School he created the community school he had dreamed of with the help of legions of parents, teachers, and volunteers. Bedford honored him with a village park memorial, a parade, and a community picnic when he retired. Announcing his death, the Bedford Historical Society called him "the beloved principal of Central School."

Rix Mills Remembered: An Appalachian Boyhood

was designed and composed in 12/15 Perpetua

by Christine Brooks

printed on 157 gsm Japanese enamel gloss stock

by Everbest Printing Co. Ltd. of Hong Kong

and published by

THE KENT STATE UNIVERSITY PRESS

Kent, Ohio 44242